BEHOLD THE PEOPLE

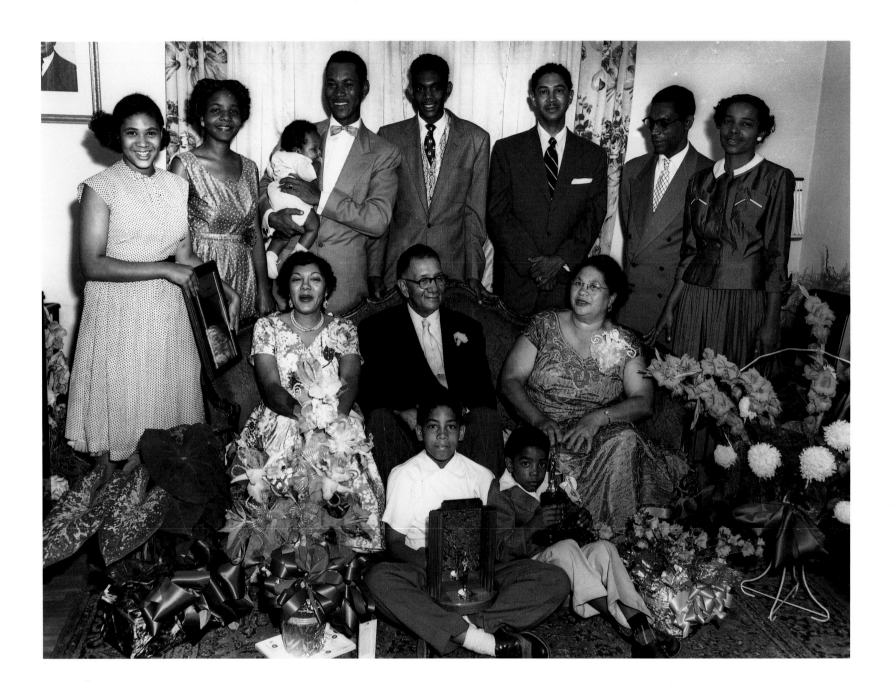

BEHOLD THE PEOPLE

R. C. HICKMAN'S PHOTOGRAPHS OF BLACK DALLAS

1949 – 1961

By R. C. Hickman

Preface by Barbara Jordan

PUBLISHED FOR THE CENTER FOR AMERICAN HISTORY BY THE TEXAS STATE HISTORICAL ASSOCIATION

Library of Congress Cataloging-in-Publication Data

Hickman, R. C., 1922–
 Behold the people : R.C. Hickman's photographs of Black Dallas, 1949–1961 / by R. C. Hickman ;
preface by Barbara Jordan.
 p. cm. — (Barker Texas History Center series ; no. 3)
 Includes bibliographical references.
 ISBN 0-87611-136-3 (cloth : acid-free paper)
 1. Afro-Americans—Texas—Dallas—Pictorial works. 2. Dallas (Tex.)—Pictorial works. 3. Hickman, R. C., 1922– —
Photograph collections. 4. Photograph collections—Texas—Austin. I. Title. II. Series: Barker Texas History Center series (Texas
State Historical Association) ; no. 3.
F394.D219N44 1994
976.4'00496073—dc20
 94-2947
 CIP

10 9 8 7 6 5 4 3 2 1 94 95 96 97 98 99

Published for the Center for American History by the Texas State Historical Association in cooperation with the Center for
Studies in Texas History at the University of Texas at Austin.

Number Three in the Barker Texas History Center Series
Senior Editor, Don E. Carleton

The paper used in this book meets the minimum requirements of the American National Standard for Permanence of Paper for
Printed Library Materials, z39.48—1984.

This book was made possible in part by a generous grant from the Meadows Foundation of Dallas.

Front cover: *Mrs. Murray's son flies home* by R. C. Hickman, 1954.
Back cover: *Bobbie the newsboy* by R. C. Hickman, 1953.
Frontispiece: *Dr. Lee G. Pinkston and family* by R. C. Hickman, 1954.

CONTENTS

This book is dedicated to Cora Hickman and Ruth K. Hickman

PREFACE

R. C. Hickman has assured that a significant part of the American experience will not be ignominiously assigned to the dustbin of history. When I look at the remarkable photographs that he took during the three decades following World War II, I am struck by the fact that he has lived (and captured on film) much of the history of black Dallas during a particularly important era. He worked as a staff member of the Dallas *Star Post* and as a freelance photographer for several newspapers and magazines and the National Association for the Advancement of Colored People.

Mr. Hickman photographed celebrities and notables such as Dr. Martin Luther King, Thurgood Marshall, Nat King Cole, Ernie Banks, and Ambassador Ralph Bunche when they visited Dallas. But his pictures show more than the celebrities. They show a life that has been in many ways invisible to the rest of America. Taken in the years prior to and in conjunction with the Civil Rights movement, these touching and powerful images document a substantial black middle class (middle class as used here must be relative when viewed against its general, usual meaning) that embodies the values and virtues of mainstream America. Contrary to the perception that nearly all black Americans have lived in poverty—and we have all seen our share of such devastating images—here is an historically significant record of accomplished, hard-working black middle-class citizens living in the urban South. Overcoming the many obstacles in their way in those years before civil rights legislation made fundamental changes, people like Mr. Hickman and those he photographed played and won by the rules, despite the fact that their color meant that they were often denied the rights and respect due them. The harrowing issue of racism, the integration of the Dallas schools, and civil rights activities are all documented here, but just as important are the less-dramatic images that tell us about the little-known or -understood middle-class African American life.

These photographs are powerful reminders that, for much longer than many believe, black Americans have been an important part of mainstream America. Only the daunting factor of race has kept them invisible. These are images of the ordinary lives of extraordinary people who succeeded in spite of all the obtacles in their path, and who eventually demanded and, in important ways, won their rights. R. C. Hickman's photographs are important documents that capture a significant moment in twentieth-century American life.

BARBARA JORDAN

FOREWORD

I first met R. C. Hickman on a late summer day in 1984. Dr. Michael Gillette and I traveled to Hickman's home in the South Oak Cliff section of Dallas to find out if he had saved any of the work he had produced during his career as a photographer in the late 1940s and 1950s. Gillette, who had recently completed work on his dissertation about the NAACP in Texas, had alerted me to the possibility of this collection's existence.

As director of a historical archive and special collections library, I was eager to preserve Hickman's photographs and to make them available for research. Also, as a native of Dallas who had grown up during the years Hickman was working as a photographer, I was keenly interested in viewing images of people living in a community only a few miles from my childhood neighborhood. In those days of institutionalized racial segregation, Hickman's community and mine might as well have been on opposite sides of the earth. I grew up in Dallas with little awareness of my fellow citizens who happened to be African American. Although the Supreme Court had ruled racially segregated public schools unconstitutional when I was a first grader in the Dallas Independent School District, I spent twelve years in racially segregated public schools. I lived for eighteen years in a racially segregated neighborhood and read and watched local newspapers and television that gave no hint of life in black Dallas, other than the tragic and sensational. As a result, my interest in R. C. Hickman's photographs may have been more personal than professional.

I was not disappointed by Hickman or his photographs, the negatives of which he had carefully filed in labeled envelopes and stored in several small boxes. Gillette and I spent the remainder of that morning fascinated by the hundreds of images documenting events large and small, happy and tragic, public and private, that marked the lives of ordinary people as they worked and played and yearned for their fair share of the American dream. I was equally impressed by Hickman, whose generous spirit, good humor, and strength of character were immediately apparent. We agreed that morning to work together to preserve and make more widely known his remarkable visual history of African American Dallas in the decades immediately following the Second World War.

After that meeting in 1984, Hickman agreed to place his photograph collection at the University of Texas Center for American History. Exhibitions of and conferences about R. C. Hickman's work followed, and his photographs finally appeared in Dallas newspapers and other publications. And now we have *Behold the People*, a book that I hope will bring back memories to a segment of African American Dallas, educate new generations of Dallasites and other Americans, and provide a tangible and permanent record of the dedicated work of a remarkable and delightful human being.

Behold the People: R. C. Hickman's Photographs of Black Dallas, 1949–1961 is the third volume in the Center for American History's cooperative publication series with the Texas State

Historical Association. This series was established to encourage and support the publication of historical studies based mainly on the Center's Barker Texas History collections. The Barker collections include the nation's largest library of Texana as well as extensive holdings of archival, cartographic, newspaper, sound, and photographic material.

Funds from the J. R. Parten Chair in the Archives of American History provided major support for the preparation of *Behold the People: R. C. Hickman's Photographs of Black Dallas, 1949– 1961*. Several individuals participated in the development of this book and in the preparation of its explanatory text. Among the most involved were Earline Montgomery, Larry Landis, Alison Beck, Sheree Scarborough, Donna J. Coates, John Wheat, and Katherine J. Adams. Sherilyn Brandenstein, who served as a consultant to this project, conducted background research and helped draft the text. Texas State Historical Association Director Ron Tyler and Assistant Director George Ward were unfailingly cooperative and supportive during this publication project, as was the Association's Executive Council. I thank them all. Finally, I must acknowledge the support of the Meadows Foundation of Dallas, whose generosity made possible the publication of this book.

DON E. CARLETON, Director
The Center for American History

INTRODUCTION

In August 1956, citizens of Mansfield, Texas, learned that three black students planned to register to attend Mansfield High, the town's all-white public school. Although the U.S. Supreme Court had ruled unconstitutional the racial segregation of public schools two years earlier, Mansfield whites were determined to resist desegregation. On the morning of August 30, white citizens gathered at the school, threatening violence if the black students appeared. Effigies depicting lynched blacks were hung on Main Street and in the school yard. The Mansfield High School principal made no effort to remove the effigies on school property (plates 103–104).[1]

Determined to photograph these effigies for the Dallas *Star Post*, a black-owned newspaper, staff photographer R. C. Hickman had his friend John Mitchell drive him to Mansfield. When they arrived, Mitchell stopped his car in front of the school, but left the engine running. "I put one foot on the ground and one foot on the running board, with my camera to my eye," Hickman later recalled. "And I clicked and I moved it around and I clicked it again."

When a group of white men drove up behind them, Hickman and Mitchell feared violence. Hooligans already had forced a white Associated Press reporter off the road and had broken another journalist's camera. The locals were no happier to see Hickman. Jumping into the car, Hickman had Mitchell drive to

nearby Fort Worth. With the Mansfield contingent in pursuit, they reached the city's African American section, where Mitchell eluded his pursuers by turning into the garage of a funeral home.

That week the *Star Post* ran the first published pictures of the Mansfield effigies to appear in a Dallas newspaper.

R. C. Hickman's historic 1956 photograph of the Mansfield effigies is one of thousands of images he produced from 1949 to 1961 while working as a commercial portrait photographer, as a photojournalist for several black newspapers in Dallas, as a freelance photographer for national black publications such as *Jet, Sepia,* and *Ebony*, and as an official photographer for the National Association for the Advancement of Colored People (NAACP). Hickman's photographs constitute an extraordinary visual record documenting life in a middle-class African American community prior to racial integration. His images depict a community largely invisible to white Americans—one thoroughly a part of mainstream America by virtue of accomplishment and life-style but excluded from it because of race. It is a record crucial to our understanding of postwar America.

Hickman began his career as a photojournalist and portrait photographer at a time when the black newspaper functioned as an important "looking-glass for black self-realization."[2] During these years white-owned newspapers rarely acknowledged in

[1] Dallas *Morning News*, Aug. 31, Sept. 1, 1956.

[2] Charles W. Grose, Black Newspapers in Texas, 1868–1970 (Ph.D. diss., University of Texas at Austin, 1972), 260.

I

print the activities of blacks except as they related to crime or poverty. As a consequence, African Americans looked to black-owned papers for news and public recognition of their accomplishments and struggles. In publishing photographs of black newsmakers such as those produced by Hickman, the black press provided evidence that helped challenge the familiar stereotypes about black life.

In Texas, African Americans found the only published imagery of themselves in their own weekly newspapers even as late as the mid-1960s. The Kerner Report of the National Advisory Commission on Civil Disorders cited the news "black-out" as a nationwide problem and called on white-owned newspapers and television stations to routinely include African Americans in their news coverage.[3] The "black-out" that excluded images of black Texans from the white-dominated media made photographers such as R. C. Hickman the essential recorders of their communities' citizenry and its accomplishments.

R. C. Hickman continued a long tradition of African American involvement in the business and art of photography. From nineteenth-century portraitists to twentieth-century urban photojournalists, African American photographers such as James Van Der Zee of Harlem, Addison Scurlock of Washington, D.C., and J. P. Ball of Cincinnati used their cameras to help African Americans counteract the negative racial stereotypes fostered by white Americans. As Deborah J. Johnson states in *A Century of Black Photographers: 1840–1960,* for the African American community photography functioned as a social record—a positive and visible statement that affirmed a people who had been excluded by the dominant culture. Such an affirmation was often realized in the image of a strong individual or family in the midst of its celebrations and its grievings.[4] Hickman's work is full of such images: beauty queens, garden-club teas, children in Halloween costumes, Friday night dances, high school cheerleaders, visiting celebrities, local newsboys, housewarmings, and religious gatherings—a roster of everyday life in one community.

R. C. Hickman's photographs also record his community's postwar struggle for racial equality. In both his life and his work Hickman was a part of the activism spurred by returning black veterans who refused to remain segregated in the very society that declared itself the freest in the world. Home from the service, Hickman laid his discharge papers on the desk of a downtown Dallas photography studio and applied for the job that launched his career. His work as an official photographer for the NAACP produced visual evidence used in school desegregation litigation and his work for the *Star Post* kept Dallas blacks abreast of the civil rights movement in North Texas. His own success and visibility as a photographer within the black community of Dallas presented a further positive image as a successful African American entrepreneur.

The black-out that excluded images of African Americans from the white-dominated media in the postwar years has also contributed to the absence of these images in our historical record. Today the R. C. Hickman Photographic Archive housed at the Center for American History at the University of Texas at Austin stands out as one of a handful of black photographic archives in the United States that supports research in the post-1945 civil rights movement and in the study of photojournalism, photography, urban studies, and African American history. Containing thousands of negatives from the period 1949 through

[3] *Report of the National Advisory Commission on Civil Disorders, March 1, 1968* (Washington, D.C.: Government Printing Office, 1968), 210–212.

[4] Deborah J. Johnson, "Black Photography: Contexts for Evolution," in Valencia Hollins Coar, *A Century of Black Photographers: 1840–1860* (Providence, R.I.: Museum of Art, Rhode Island School of Design, 1983), 15.

1961, it helps fill a critical gap in our recorded history by preserving a valuable visual record of Dallas life "black-wise," as Hickman would say.

Rufus Cornelius Hickman, the third of Cora and Norman Hickman's four children, was born on August 26, 1922, in Mineola, an East Texas cotton town located between Dallas and Shreveport, Louisiana. His parents worked as cooks, one for the town banker, the other for a hotel. Cooking for white families and businesses was a common job for African Americans in the interwar years.

When the Texas economy tightened, however, Norman Hickman felt that he had to leave Mineola to improve his economic status. The splitting of black households for economic reasons was not uncommon during this period. Norman moved to Dallas with Norman Jr., the eldest child, and with twelve-year-old R. C. For several years, the elder Hickman worked at the Baker Hotel as a cook. Then he became a Pullman porter on the Texas & Pacific Railroad. The move to Dallas proved profitable. Although many Texans merely survived the Great Depression, some escaped its direst effects. R. C. Hickman counts himself among the fortunate American children whose parents had steady work throughout the 1920s and 1930s. "I had more clothes [than others]. I would have a short-pants suit and the long pants that came with it. That is, I had a suit with two pairs of trousers. A lot of kids didn't have that privilege," he recalls.

R. C. also remembers the benefits of a caring, close-knit family. The Hickmans, like many southerners, were in transition between rural and urban life, and R. C. bounced back and forth between Mineola and Dallas, spending alternating years of grade school, as well as summers and holidays, with his mother in East Texas. When in Dallas, he stayed with his father or with his aunt and uncle, Mr. and Mrs. C. L. Walker. In each household, he was nurtured, disciplined, and taught the middle-class values of his family. He remembers learning to cook by watching his parents. His father also taught him to save part of his earnings. "I think I was brought up pretty good," R. C. says. "I didn't have any problems like kids do now."

Indeed he seems always to have been under the watchful eye of family and friends, even though he changed households periodically. Hickman remembers that his father was prone to have disagreements with landlords. When this occurred, Norman Hickman generally found new quarters, moving his family only a few blocks from their previous residence. "We lived all up and down Thomas Avenue between Hall and Fairmount," R. C. says, remembering the adjustments.

If uncertain of his next address, the young Hickman certainly knew this African American neighborhood intimately. At the time, Thomas Avenue and Hall Street were at the heart of a prominent black residential sector in North Dallas, a metropolis as racially divided as most in that period. On Thomas Avenue, middle- and upper-class blacks displayed their achievements in the form of gracious residences. Doctors, hoteliers, teachers, and morticians owned homes on or near the thoroughfare. Farther north, a theater, fine restaurants, and clubs flanked doctors' offices, a drugstore, and a barber shop. Hickman's early experiences were firmly rooted in this black urban middle-class environment, which he later documented with his photographs (plates 1–4).

The city's black children attended B. F. Darrell Elementary School, located several blocks east of Thomas Avenue at Cochran and Hall. The Black Elks Club building and a grocery faced each other across the street nearby. St. John Missionary Baptist Church, a hub of social and spiritual life in North Dallas, was located at Guillot and Allen, beyond the railroad tracks to the west (plate 58). South of the church, the city had created a park

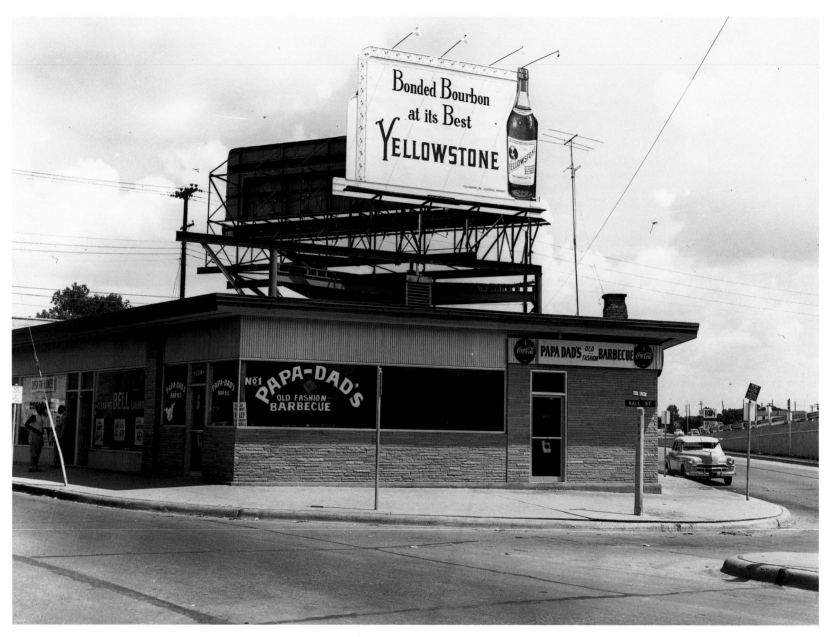

1. Papa Dad's Bar-B-Que, 1954.

"This was the spot. On the next corner was Dr. Pinkston's clinic, on the other corner was the State Theater, and on another corner was Smith Bros. Drug Store."

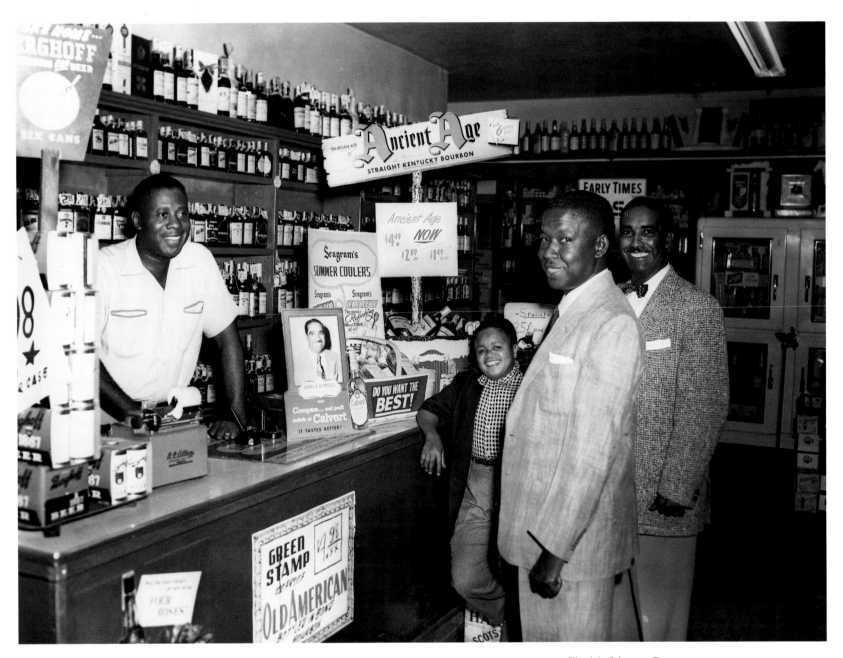

2. Clark's Liquor Store, 1954.

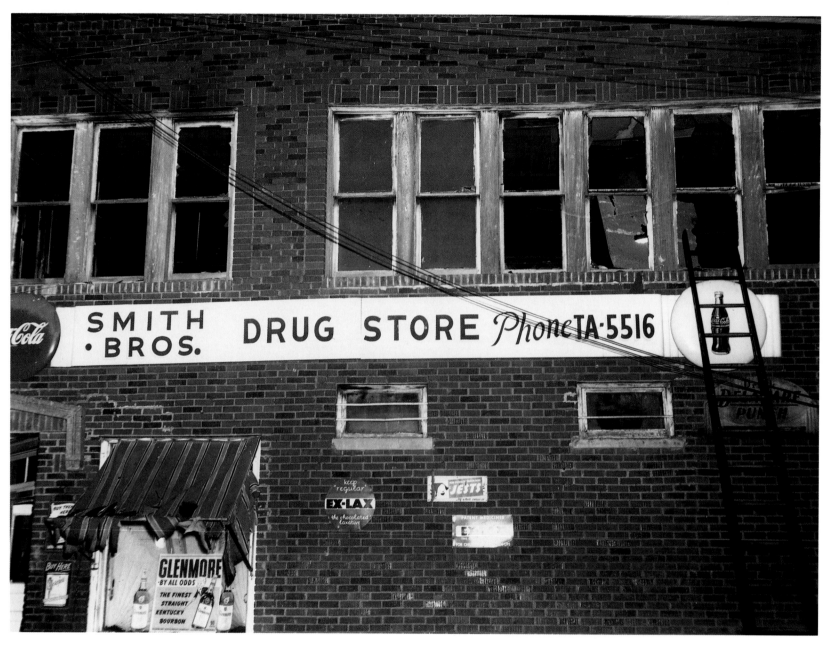

3. Smith Bros. Drug Store (fire), 1954.

"This area was black-owned and -operated and was looked upon as a very important part of Dallas's black life."

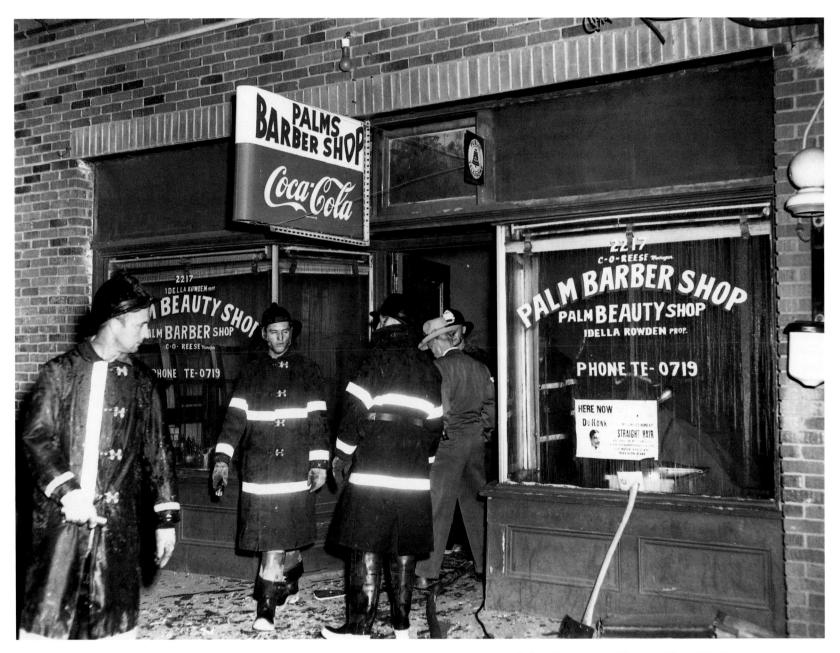

4. Palms Barber and Beauty Shop (fire), 1954.

with a clay tennis court specifically for its black citizens. As a teen, R. C. Hickman learned to play the game there.

In the 1930s, Dallas County's African American teenagers attended Booker T. Washington High School at Flora and Routh. Hickman enjoyed learning, and his academic standing earned him a coveted membership in the Older Boys Conference at the school. He also played interscholastic basketball and tennis. At St. John Missionary Baptist Church, Hickman joined the junior ushers, strengthening his commitment to church life and social ties with other church members.

Over time, these church friends would significantly influence his careers in sales and photography, although his interest in the former seems to have been instinctive. "You know, I wasn't just satisfied with playing like the other kids," he says. "I wanted a job. I wanted to be *doing* something, selling something . . . just making a little nickel or dime." With his parents' encouragement, R. C. sold garden seeds, newspapers, and magazines such as *Collier's* and *The Woman's Home Companion* (plate 5). By age fifteen he had begun peddling the Dallas *Morning News* and the Dallas *Dispatch*, white-owned newspapers popular among his neighbors.

Although work kept Hickman busy, it did not prevent him from participating in the same pastimes his friends enjoyed— pitching pennies on "the Block" or catching the movies at the State Theatre at Thomas and Hall. "When I was selling the Dallas *Dispatch*, I would make the theater the last paper that I delivered. So, you know, [I] had to go in," he explains. "When I go in, I'm *in*. So I'd see every picture—sometimes I'd see it two or three times!"

Much as he loved the attractions of Dallas, Hickman maintained his connection to Mineola. Upon graduating from high school in 1937, he returned there to help run a family store and cafe (plate 6). The stay was brief. In 1938 a tennis scholarship enabled him to attend Methodist-affiliated Tillotson College, a black school in Austin, Texas, where he completed two years of study.

After the U.S. entered World War II in December 1941, Hickman received a draft notice ordering him to report for basic training in February 1942. By the time he left Texas, he already had experienced the sound of bombs and the threat of danger. In 1939 his aunt and uncle, the Walkers, had been among those forced to sell their homes in North Dallas to make way for the federally sponsored Roseland Homes Housing Project. They found a suitable home in white, middle-class South Dallas. As the Walkers and other blacks began moving into that area in the summer, they encountered resistance from white neighbors. Bombings and sporadic shootings caused them to enlist friends and relatives to guard the home for several weeks until the violence abated.

Despite the discrimination they faced at home and in segregated military units, thousands of African Americans joined the armed services during World War II. Hickman was assigned to quartermasters' school after basic training. He learned transportation and supply operations and trained in carpentry for shipping and storing ammunition. Following a stint in Hawaii, he reported to Saipan in the Mariana Islands. There, his unit supplied the Fourth Marine Division.

As a noncommissioned officer, Hickman supervised a crew of captured islanders in loading and moving supplies. "By signs, by demonstrations, I showed them how to do whatever my commanding officer told *me* to do," he says, explaining how he overcame the language barrier. This was the first of many opportunities he would have to train others. He also spent harrowing nights in foxholes avoiding Japanese fire. From Saipan, his unit could see the eerie light after U.S. pilots bombed Hiroshima, hundreds of miles away.

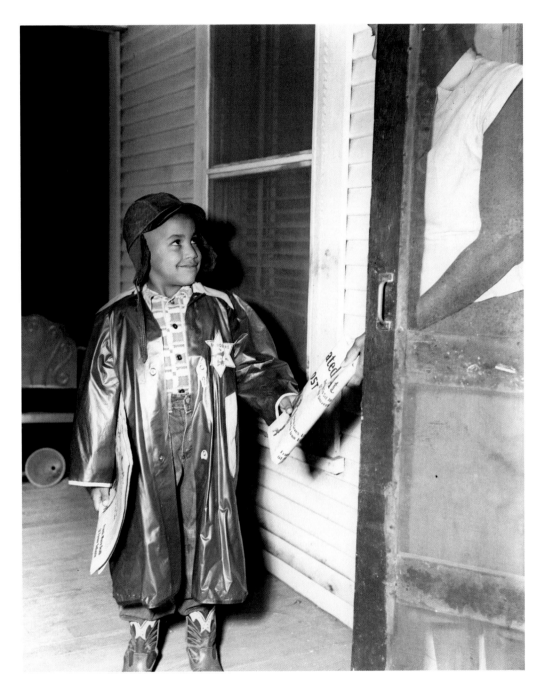

5. Young newscarrier delivering paper in coat and cowboy boots, 1954.

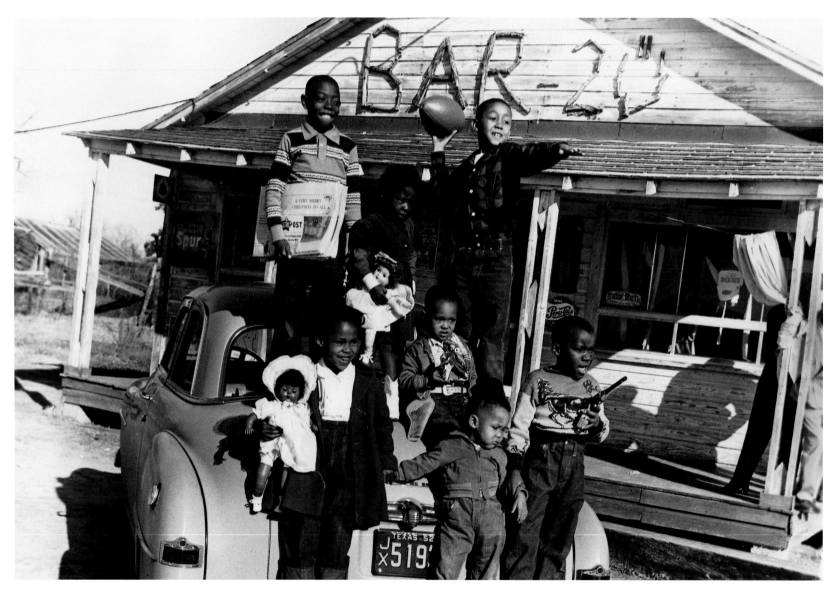

6. Hickman family-owned BAR-20 store in Mineola, Texas, and neighborhood children, 1952.

The first BAR-20 was built in 1937. It burned down and was rebuilt by R. C. in 1945 after he was discharged from the U.S. Army. Top, left to right: Cleophus Walton Jr. and B. Walton (parents Cleophus and Lee Helen Walton); Marvin H. Sampson (parents Howard and Mary Jane Sampson). Bottom, left to right: Catherine Herndon, Joseph M. Herndon, and Lafayette Herndon (parents Rufus and Vivian Herndon); Billie Lee Walton (parents Mr. and Mrs. Donnie Lee Staples).

"When I was in the service, I sent all my money home to my mother."

Along with these challenges, he gained a new skill. Observing a Marine developing reconnaissance photographs in a foxhole, Hickman asked to learn the process. Over several months, he took photographs in an unofficial capacity, developing them in his free time. Soon he began to receive assignments from the photographer who had trained him. By the time of his discharge in late fall 1945, Hickman had papers certifying his status as an official army photographer.

The war's end brought transitions and decisions for many young veterans. So it was for the twenty-three-year-old Hickman. He returned to Texas, rejoining his family and experimenting with a new career. His first priority was to help his mother rebuild the family cafe, which had burned down during his absence. He then took a job as a darkroom technician at the Hall Gentry Photographic Studio in downtown Dallas, applying what he had learned in the service. On some weekends he still made trips to Mineola.

Hickman renewed old friendships and developed some new ones. He became particularly attracted to a petite elementary-school teacher, Ruth K. Johnson, who lived around the corner from his aunt and uncle. She had attended his high school, but they had associated with different groups then. Now back in Dallas—he from the service and she from Bishop College—they began a relationship. She invited him to be her escort for a few parties late in the social season. "All of a sudden I found myself getting close to Ruth," Hickman says. "She was dainty and sweet." They began planning their wedding just a few weeks after their first date, and were married in June 1946.

Hickman soon realized that he needed more income to supplement Ruth's salary from teaching and more formal training in photography than his job in the darkroom would provide. He applied for G.I. benefits in 1946 to enroll in the Southwest School of Photography in Dallas, which offered instruction in photographic and darkroom techniques, portrait and free-lance work, and business. "We would go on field trips and we would shoot sceneries, shoot houses, shoot trees, shoot skylines," he recounts. "Sometimes [someone] would call the school and they would need coverage like a birthday party or like someone arriving on a plane—some event. And since I had experience prior to coming to the school, I was the one they mostly used for that."

At first Hickman used borrowed cameras, but by the end of his two-year schooling he was making installment payments on a 4 x 5 Speed Graphic (plate 7). Hickman preferred photographing groups, and this large-format camera allowed him to capture detail at a distance. Fortunately, too, the 4 x 5 Speed Graphic's negative size and format were optimal for making images for newspapers, enabling R. C. to begin accepting photographic assignments from the Dallas *Express*.

Established in 1892 and still operating, the Dallas *Express* is one of the nation's oldest African American newspapers. Although Carter Wesley, its longtime publisher, challenged the status quo by accepting civil rights cases in his legal practice, he published relatively staid newspapers in the *Express* and the Houston *Informer*.

Wesley printed the Dallas *Express* in Houston, obtaining articles and images from Dallas correspondents. Hickman approached Wesley for a job with the *Express* after he completed photography school in 1948. Wesley didn't hire Hickman outright, but offered to teach him to sell ads for the paper and to give him photo assignments as they came up, which the paper would pay for on an individual basis. Even though the pay was minimal, Hickman appreciated the chance for experience and accepted the *Express* "internship."

When he returned to Dallas after military service, Hickman resumed active membership in St. John Missionary Baptist Church. St. John, with its large middle-class membership, be-

came another source for picking up commercial photography assignments. In addition, Mrs. Augusta Andrews, the Dallas agent for the Kansas City *Call* and also a member of St. John, approached Hickman about replacing her when she retired. Becoming the local agent of a Midwestern weekly paper meant a promotion for Hickman, and he agreed to take it on. Hickman's responsibilities as Dallas-area agent for the *Call* included selling the paper and photographing local events for publication.

The Kansas City *Call*, published by Chester A. Franklin, emphasized local news coverage of black communities in the Midwest and Southwest. Rather than running sensational crime stories to boost sales, as many papers did, Franklin preferred to report on and protest discrimination and violence against blacks. Appealing to middle-class readers with a mix of political and religious news and cultural features, the *Call* developed a healthy regional circulation.

R. C. Hickman did his best to increase the newspaper's sales in North Texas. From an office on the corner of State and Routh streets in "Short North Dallas," he solicited advertising, managed distribution, and produced news stories and photographs. Hickman believed that selling newspapers required promoting Dallas citizens and their social affairs. Accordingly, he set out to recruit Dickie Foster, a columnist at a neighborhood record outlet who kept up with the local social scene and with popular music. Hickman persuaded her to contribute a weekly column, called "Platter Chatter," to the *Call* (plate 31).

Hickman knew that African Americans were hungry to see public notice of their everyday lives. Hickman convinced Foster that if she could weave local society news in with notes about black recording artists, her column would benefit both his newspaper sales and her record business. For each Dallasite whose name was mentioned in the paper, Hickman figured he could count on several papers being sold—one to the subject and others

to his or her relatives. Hickman's strategy paid off. Neighborhood stores that originally sold eight or ten copies of the *Call* per week steadily increased their sales to several score weekly. Within months, he had developed a circulation of eight hundred newspapers in the Dallas-Fort Worth area.

The postwar surge of weddings, births, and soldiers' furlough visits that continued into the 1950s, plus Hickman's hard work and strong community ties, meant more customers for his commercial photography business. Hickman was able to use the studio and darkroom of his *Call* office, and later those at the *Star Post*, for his own business. In addition, he had a darkroom at his home. His wife, Ruth, played an integral role in the business by taking appointments for him, attending events to help set up shots, taking care of bookkeeping or secretarial necessities, and helping to keep R. C. awake during late-night darkroom work.

Hickman had no interest in studio work. Rather, he carried his Speed Graphic to subjects' homes, churches, or parties to render portraits. "He was purely professional," family friend Jewel P. McKenzie remembers. "He would tell you in good terms where to stand . . . and what to do for the best coverage of your event. But he would never seem to be directing it. He would do it in such a way that you'd follow what he said, but you wouldn't be ordered to do it. He was smooth with it. And he knew enough about events that he was covering to really have a feel for what he was doing," she adds. "He knew what would attract people's attention."[5]

Hickman particularly sought out large groups to photograph because they guaranteed greater sales. "[There were] a lot of social clubs in Dallas . . . and all these social clubs would have their affair during the spring or winter," he says. "They would always want their pictures made. Normally it was my goal to sell everybody *in* the picture a picture for himself."

[5] Jewel McKenzie to Sherilyn Brandenstein, Aug. 11, 1990, interview.

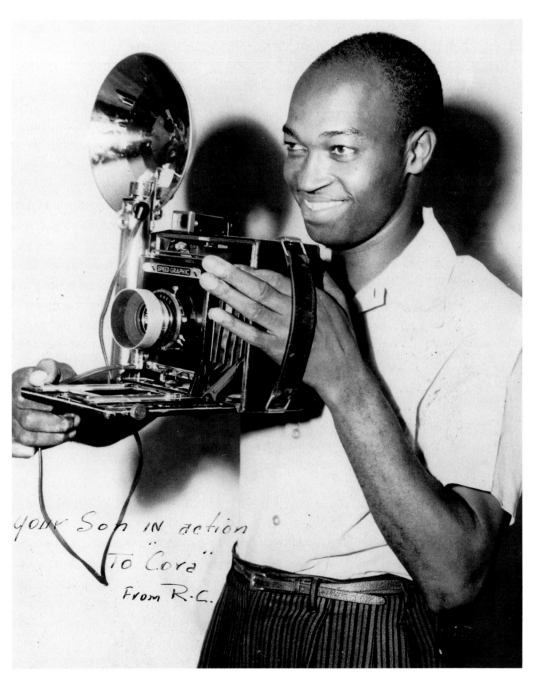

Your Son IN action
"To Cora"
From R.C.

7. R. C. with Speed Graphic camera, by
unidentified photographer, 1949.

"The boys now have all kinds of lighting equipment
to take their pictures. I had one light but I could take
it off the camera and hold it where I wanted to give
the effect I needed for that photograph."

More than money motivated Hickman to render favorable images of friends and neighbors. "We were [viewed as] second-class citizens and we had to prove that we were not," he remembers. During the 1950s, as blacks faced racial slights, bombings, and land-grabbing, they were determined to celebrate their existence, individually and communally. R. C. Hickman saw to it that his customers had prized images of such celebrations.

From this early period in his career Hickman produced a photograph of West Dallas school children performing a May Day dance (plate 8). Posed in a classical arrangement, they presented a counterpoint to their dusty surroundings. Just months before, black Dallasites had gathered along the streets near Fair Park for the annual State Fair parade on Negro Day, the only time they were admitted to the fair. The injustice of the State Fair policy did not prevent young parade participants, such as Miss Wiley College of 1950, from enjoying the festive possibilities of a beautiful autumn day in the city (plate 74).

R. C. Hickman's combined success with photography and newspaper sales brought him to the attention of Rev. E. C. Estell, the patriarch of St. John Missionary Baptist Church. Heading one of the largest congregations in Dallas's African American community, Estell was becoming a liaison between the racially divided sectors of Dallas. He represented the black Interdenominational Ministerial Alliance and served on the Biracial Committee of the Dallas Chamber of Commerce. A conservative Baptist, Estell endorsed Booker T. Washington's philosophy of Negro self-help, and practiced what he preached by investing in local enterprises and property.

A member of the board of directors of the Dallas *Star Post*, Estell wooed R. C. Hickman away from the Kansas City *Call* in 1952, stating that he wanted Hickman to devote his considerable energy to a local enterprise rather than to an out-of-town newspaper. Estell assured Hickman that the move would be financially advantageous. To sweeten the offer, the *Star Post* appointed Hickman its key photographer, as well as circulation and advertising manager (plates 33–40). Hickman retained all three positions at the *Star Post* for nearly a decade.

He also continued to promote his own photography business. With Ruth still teaching school and R. C. juggling two sales and two photographic positions, the couple led busy, social lives. Looking back on that period, Hickman remembers the weekly schedule he worked out to meet all his responsibilities.

"Monday was a day that I set aside to get new agents to handle the paper," he says. "I'd go to Terrell, Fort Worth, Corsicana . . . I'd go as far as Marshall. . . . [Monday] was the day I'd set up my contacts, because Tuesday I had to be in the darkroom getting my pictures ready, because we had to go to press on Wednesday. We'd stay up all night getting that paper out."

Then the distribution work began. "I would mail [the paper] on Wednesday night about two or three o'clock in the morning. It was a Thursday, really," he remembers. "I loaded my Jeep up with papers to carry to my boys, to my stops." Hickman worked one quadrant of the Dallas area himself and had two or three assistants to distribute to the other areas. In his decade of managing circulation, he also hired and trained scores of African American newsboys in Dallas (plates 41, 42).

"Friday was the leisure day . . . I don't even have to go to the *Star Post* that day if I don't want to, because I've already put in forty or fifty hours anyway," he says. This arrangement conveniently gave Hickman time to pursue commercial photography on the weekends. Parties, dances, and weddings gave him jobs all over town and sometimes out of town. Ruth often accompanied him to these events and was particularly an asset at weddings, where she helped the brides prepare their appearance for the photographer (plate 9).

Sometimes *Jet* magazine hired Hickman for celebrity assign-

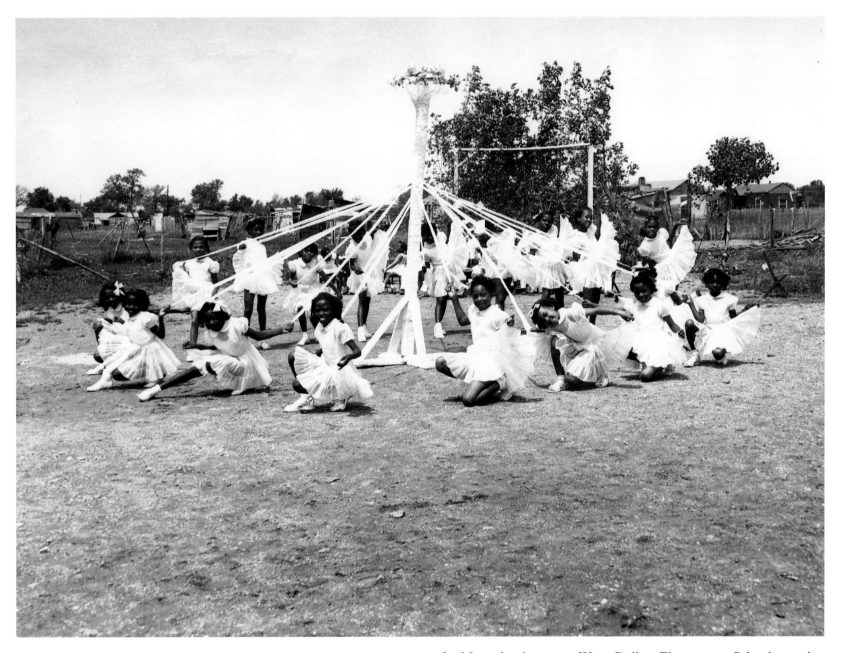

8. Maypole dance at West Dallas Elementary School, teacher
Ms. Georgia Prestwood, 1950.

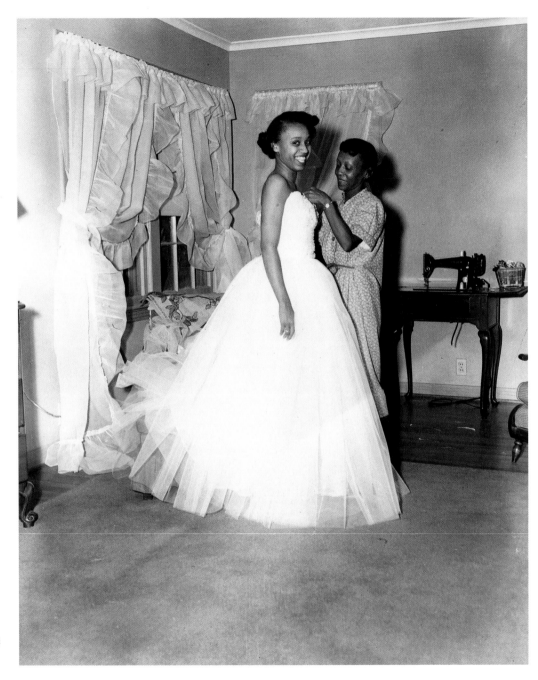

9. Mrs. R. C. (Ruth) Hickman and debutante
Shirley Elliott, 1961.

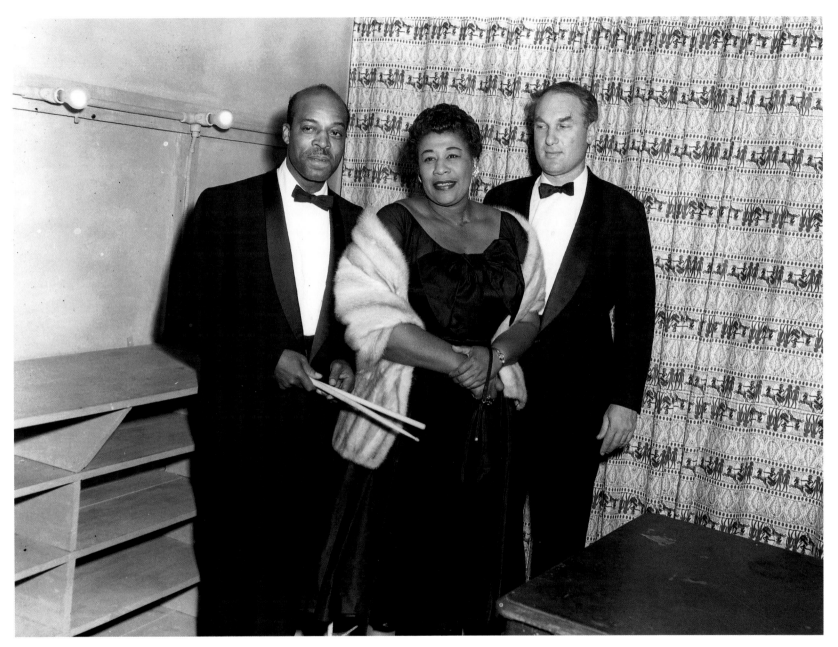

"When she finished performing at the Music Hall, Ella Fitzgerald was like any other black in Dallas—she couldn't check into the Adolphus."

10. Ella Fitzgerald, 1956.

ments. National black publications many times relied on local black photographers to capture events that would interest their readers. Hickman's newspaper work, his connections with local black publishers and photographers, and his ability to produce high-quality photographs made him a logical choice as a local photographer for such national publications. The assignments typically required Monday-night trips to the Longhorn Ranch House, a popular Dallas nightclub that country music star Bob Wills owned for a time. Throughout the 1950s, the club's management allowed African Americans to attend performances on Mondays only. Hickman photographed many top musicians there: balladeer Nat King Cole (plate 92), jazz vocalist Ella Fitzgerald (plate 10), and vibraphonist Lionel Hampton (plate 91), among others.

At nightclubs, Hickman also circulated among patrons, offering to take pictures for delivery later. "I didn't use a Polaroid [camera]. Never!" he remarks. "I didn't like that idea, because I wanted to develop my pictures so I could see what I was doing. But a Polaroid, you shoot it, and it comes out right then. . . . And if it's good, it's good. If it's not, there is nothing you can do about it." Hickman said that he never cut corners when processing negatives. He told customers, "My pictures will last as long as you do."

The care Hickman invested in his photographs partially accounts for their lasting value. Equally significant, however, is the scope of his subject matter. During the 1950s and early 1960s, most blacks in the United States were pressured to remain invisible to whites, except when in service functions. After World War II a minority of the black population began publicly challenging this limited status. Black veterans especially sought equal access to benefits promised to all G.I.s, such as financial aid for housing and college, plus preferred hiring status. Having helped win victory abroad, they called on the state and federal governments to guarantee civil and economic rights at home.

The veterans' interests merged with an organizing momentum already advancing through black communities. The NAACP had increased its membership ninefold, to 450,000, during the war. The association worked through the courts and mass media to promote racial equality, while a newer group, the Congress of Racial Equality (CORE), took direct action, particularly against economic discrimination plaguing persons of color. The National Urban League, founded decades earlier, kept up pressure for equal opportunities in housing and middle- and upper-level employment. All three organizations had their strongest bases of support in cities, where the African American population had concentrated.

In Dallas, African Americans who had the qualifications for well-paid jobs or had the money for desirable housing, clothing, and leisure activities encountered barriers to acquiring them. Some began to push for desegregation. They picketed segregated theaters and restaurants (plate 98). Department stores where blacks had been denied the right to try on clothing received formal complaints, and eventually they also were picketed (plate 108).

The NAACP worked to increase its membership and activity in the Dallas area during the 1950s. The association protested racial segregation in stores and public accommodations and brought suit to force the Dallas Independent School District to initiate racial integration in public schools. R. C. Hickman was drawn into these NAACP campaigns as an official photographer in 1949 because of his photographic experience and his association with W. J. Durham, the NAACP's key Texas attorney and part-owner of the Dallas *Star Post*. As a result, Hickman compiled a visual record of the organization's activities for more than a decade.

In October 1955, Juanita Craft of the association's Dallas chapter organized young African Americans to protest publicly

11. NAACP photo, 1951.

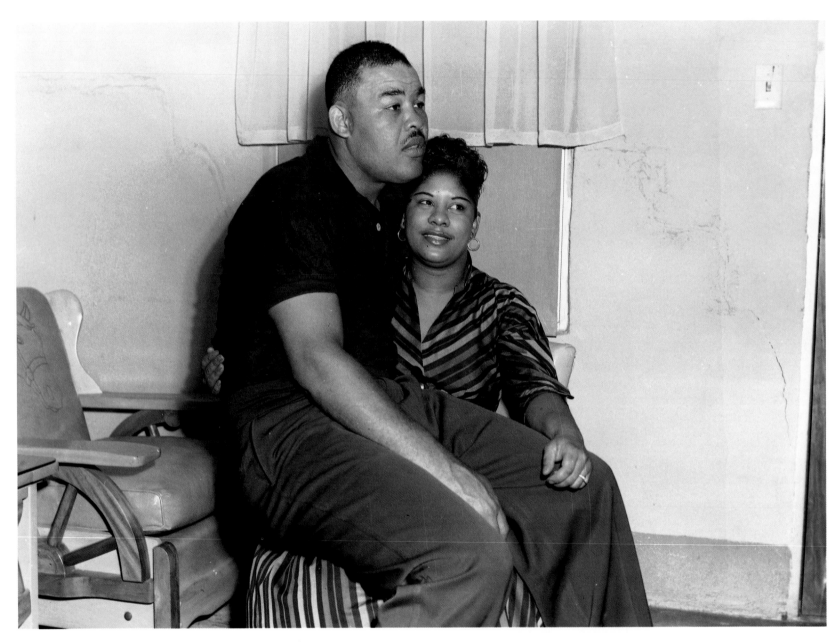

12. Joe Louis and Ruth Brown at the Aristocrat Restaurant, 1953.

"Joe Louis, heavyweight champion of the world, could not stay at a downtown hotel. He stayed with a black family. The Aristocrat was our place. It was the only place we could go."

outside the State Fair on Negro Achievement Day. Their placards called for a boycott of the fair to achieve an integrated admission policy. For years, Hickman had been hired to photograph such Negro Achievement Day events as the parade, twins contests, and beauty queen competition (plates 74–78). Now, he also worked at the fairground gates, documenting the NAACP youth campaign (plate 97). Dallas blacks associated with social change, from picketers to victims of racial violence such as a young man beaten because he belonged to the NAACP (plate 11), found themselves portrayed by Hickman.

Durham encouraged Hickman to publish images of NAACP activities in the *Star Post*. "The *Star Post* [publishers] knew that the white press was not going to cover our demonstrations and picketing for equal rights," Hickman says of the civil rights activism. "We wanted to be sure that the blacks knew what was going on. The only way they were going to really know it was to put it in [our] newspaper."

Other Hickman photographs were used as evidence when the NAACP brought suit to force school districts to initiate racial integration in public schools. The NAACP's plan to bring civil suits against segregated public school systems across the country was intended to persuade the courts that racially segregated schools did not provide equal education for whites and nonwhites. As early as 1949, Durham began taking Hickman along as he conducted surveys comparing Texas public school facilities for white children to those for blacks. A federal court order in hand, they visited many small-town schools (plates 101–102) and compared Dallas's all-white Woodrow Wilson High School to Booker T. Washington, Hickman's alma mater.

In each case, they brought pictures and statistics to court to prove that Texas provided unequal education for its black and white students. Hickman took the stand several times to testify that his images accurately reflected the disparate conditions at schools for whites and those for blacks. "This is the question that the attorneys would ask," Hickman recounts. "'You took both pictures here. This is a black school and this is a white school. . . . Now are you sure that you didn't finagle or do any finessing with the kind of material that you used from one school to the other?' . . . So I had to testify that I did not do any distortion . . . [that] I didn't overdevelop or underdevelop to make [the disparity between schools] look worse than what it was. I had to be sure that I'm showing true photography." One attorney tried Hickman's patience by implying that he might have rearranged littered wood at a black school in La Grange to add to the school's dilapidated appearance. "I just shot what I saw. I didn't move anything," he responded. "I made it my business to make no disarrangement—just shoot what it is."

Durham won all but one case in the Texas school desegregation effort. He had help in this effort from Dallas attorneys C. B. Bunkley and U. S. Tate and from Thurgood Marshall, a future Supreme Court justice (plate 99). Even so, it was ten to twenty years later, in the 1960s and 1970s, that Texas school systems finally moved toward the standard the U.S. Supreme Court had set with *Brown v. Topeka Board of Education,* requiring racially integrated public education.

Hickman also photographed national black leaders who visited Dallas. His images include Ralph Bunche, the undersecretary of the United Nations, who visited in 1954 (plate 107); the NAACP national convention in Dallas that same year (plates 58, 100); and Roy Wilkins, president of the association, who returned in 1956 to speak at local churches. In the spring of 1956, Hickman also took pictures of the up-and-coming Rev. Martin Luther King Jr. preaching at Good Street Baptist Church (plate 106), then charming the guests at a reception.

Hickman coveted assignments to photograph newsmakers, whether in the political or cultural sphere. In addition to the Wil-

kins and King images, his collection includes performance shots of Billy Eckstine and Ruth Brown, both popular vocalists in the 1950s (plates 88–90), as well as of Joe Louis, the heavyweight champion boxer (plate 12). When native Texas singer Etta Moten appeared in Dallas, Hickman captured her as she signed autographs for fans (plate 86).

Publication of these images in national black magazines helped reassure black Dallasites that their city was gaining national visibility. Hickman's celebrity portraits appeared in Good Publishing Company's *Sepia* magazine and Johnson Publications's *Jet* and *Ebony* magazines, periodicals that tracked the successful careers of black performing artists and professionals in business, government, and athletics. Such magazines nourished the rising expectations of urban blacks after the war. Published portrayals of black achievement testified to the fact that some blacks had been able to overcome the obstacles of racism and poverty, giving hope to others who strove to duplicate their success. One such successful black was Dallas native Ernie Banks, a shortstop-first baseman for the Chicago Cubs and the National League's most valuable player in 1958 and 1959 (plate 80).

Hickman's practice of selling his work to these national black magazines was common for black photographers at the time. In southern cities, black photographers competed with each other for commercial work within the black community. Many times the level of compensation for their services required them to take second jobs, such as teachers, postal clerks, ministers, or salesmen, as well as to seek other venues for their work. There was a group of black photographers operating in Dallas along with Hickman, and although they competed for work, they also developed an informal support network. Generally, they all charged comparable fees for comparable photographic services, and they helped each other in a pinch. Hickman developed amicable working relationships with photographers Dewitt Humphrey, Joseph Stewart, Cato Brown, A. B. Bell, and Marion Butts, as well as Fort Worth photographer Calvin Littlejohn.

In effect, working for national as well as local publications created two professional peer groups for Hickman and other black photojournalists during the civil rights era. When he shot local events and activities for the various black newspapers, Hickman's photographic peers were his fellow black photographers. When he shot images for national publications or when the local scene became national news, as in the case of school desegregation, his peer group broadened to include both black and white photographers. Whether at a crowded nightclub, a press conference, or a political rally, he encountered more white photographers on assignment as the age of racial segregation began to wane in North Texas. Even when together, however, black and white photojournalists sometimes represented the same event differently, since black periodicals served a specialized readership. For example, Hickman's photograph of the desegregation of City Park School in Dallas (plate 109) included several white reporters covering the event in addition to the black family arriving to start school. When his images of the event appeared in the Dallas *Star Post*, a long shot of the school also referenced its setting for readers.

In Dallas success was, and is, measured primarily in entrepreneurial terms. As Nicholas Lemann has written in his essay "Power and Wealth," "The pursuit of wealth is openly the basic theme of urban life in Texas, more than elsewhere. Status in the big cities is much less complicated, because it correlates almost exactly with money. The inheritors of fortunes are considered much less admirable than the makers of them here, which is exactly the reverse of the situation in the East." He added that

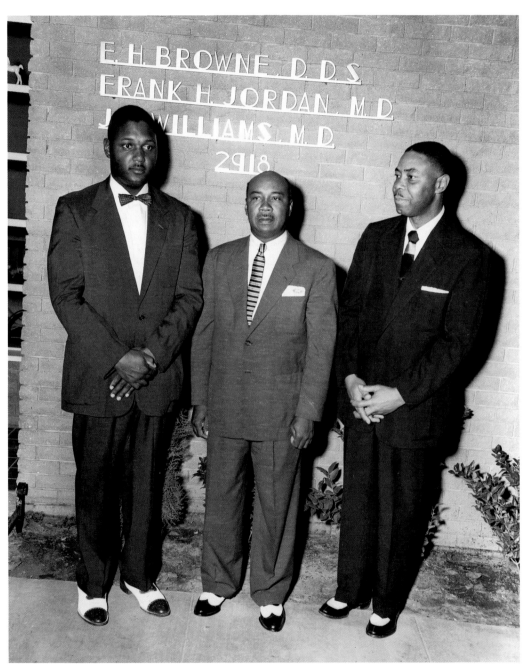

13. Medical Clinic, 1954.

Left to right: Drs. Joseph Williams, Frank Jordan Sr., and E. Holmer Browne.
"In the late 1940s black people were not admitted to the public hospitals in Dallas. So the black doctors created their own hospital."

African American life in Texas also is characterized by "its strong entrepreneurial streak."[6]

As early as the 1860s blacks had created Freedman's Town, concentrated in Dallas's First Ward but encompassing much of the present downtown business district and extending north to Freedmen's Cemetery. Historian Vivian Williamson Johnson states that the first-generation free blacks in this community included a variety of tradespersons and a professional entrepreneurial class.[7] Their turn-of-the-century businesses set precedents for the black-owned stores, restaurants, and offices that a young R. C. Hickman patronized in the 1930s and 1940s.

After World War II, the numbers of black entrepreneurs grew because more blacks had been able to accumulate capital when wartime demands pushed up wages. Also, the segregation policies of many white businesses continued to force black customers to purchase certain goods and services in their own neighborhoods. R. C. Hickman was part of this black entrepreneurial elite in Dallas as the owner of his own commercial photography business and as a professional photographer for Dallas's black-owned newspapers.

During the 1950s, North Dallas blacks continued supporting older businesses while also developing new ones. Pharmacists, barbers, auto mechanics, doctors, and retailers all posed for Hickman at their establishments, many in the State Street-Thomas Avenue business district. Some entrepreneurs, such as Drs. E. Holmer Browne, Frank H. Jordan Sr., and Joseph R. Williams on Thomas Avenue, wanted themselves portrayed in Hickman's photographs (plate 13). Although he enjoyed documenting the camaraderie at businesses such as Clark's Liquor at Hall and Thomas, *Star Post* assignments sometimes took him to scenes of loss, as when the Palms Barber and Beauty Shop and Smith Bros. Drug Store caught fire in 1954 (plates 3, 4).

Hickman could not know at the time that photographs such as these would be the only lasting record of the appearance and ambience of these establishments. During the next two decades, land developers and the City of Dallas collaborated to strip black North Dallas of its business district and most of its residences. Because the area was close to downtown and land on which to build was becoming scarce, black North Dallas became attractive to white developers. "Short North Dallas," an area that used to support a thriving, diverse black community, gave way to highrise apartment buildings and shopping centers. This gentrification of downtown black Dallas was part of a national trend, occurring in many urban areas from the 1960s through the 1980s. But by 1990, the previous intersections of commerce in the State and Thomas area had reverted to vacant lots. Of course, the city's black business life did not stop; the businesses that survived moved east and south. Thus, ironically, the success of black entrepreneurs who could move into the mainstream in the post-civil rights era led to the collapse of middle-class black neighborhoods.

As the number of black entrepreneurs multiplied in the 1950s, several saw the need to improve business practices and to expand their markets beyond a predominantly black clientele. Hickman, for example, met with Edward L. V. Reed and others to form the Pylon Salesmanship Club in 1958. During the next two years he served as club president. Eventually, the club joined the National Business League, a self-help organization founded by Booker T. Washington. Although Pylon became known for networking and promoting education for young black people, Hickman at one time headed a Pylon boycott committee that persuaded several major Dallas companies to hire and promote more blacks.

[6]Nicholas Lemann, "Power and Wealth," in *Texas Myths,* ed. Robert F. O'Connor (College Station: Texas A&M University Press, 1986), 166.

[7]Vivian Williamson Johnson to Sherilyn Brandenstein, Feb. 1, 1991, interview.

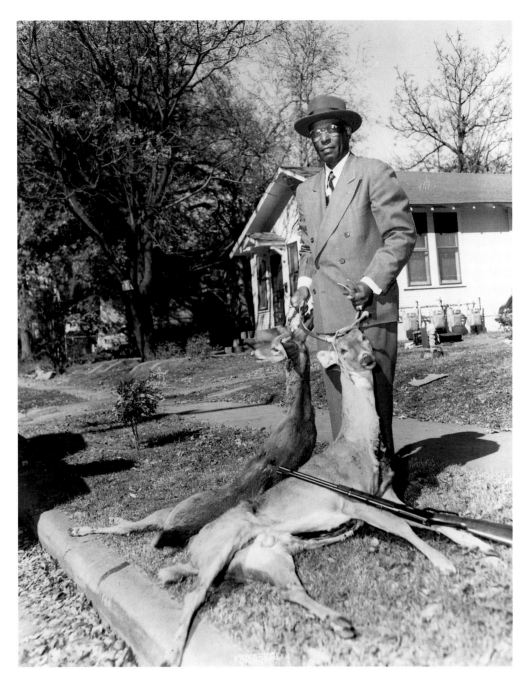

14. Rev. Brooks E. Joshua and two slain deer, 1954.

15. Mr. Green's housewarming, 1956.

Compared with many American cities, Dallas developed its industrial base rather late, and had not, therefore, attracted black immigration at the close of the Depression. The black percentage of the city's population actually declined during World War II. In the 1950s, however, increasing numbers of blacks fled joblessness in rural Texas and relocated in the cities such as Dallas and Fort Worth. Immigrants from the country crowded into Dallas County's black wards, some settling among more affluent neighbors who had preceded them by generations. Newcomers or natives, Dallasites peopled most of R. C. Hickman's photographs.

For the person in transition, Hickman's camera captured signs of older values juxtaposed with new status. For example, he portrayed Rev. Brooks E. Joshua in his Sunday best standing before a well-trimmed lawn with his rifle and two recently bagged deer beside him (plate 14). The man's satisfaction is seemingly derived from this urban location as well as from the hunt that had drawn him away from it, back to the country. In another image, a mother, equally pleased, welcomes her son home from the U.S. Navy in 1954 (plate 66). The son's uniform signals his new adult status, and his arrival by plane suggests full participation in modern life. Although few black Texans had experienced commercial airplane travel in the mid-1950s, here was a youth who embodied change. Joyfully embracing family, he also symbolized enduring values.

Next to family ties, home ownership was, and is, high on the list of Americans' priorities. Following World War II, more African Americans than ever before sought to purchase homes. Despite the severe housing shortage blacks encountered, many in Dallas moved into their own housing during the 1950s, sometimes integrating traditionally white neighborhoods in the process. Though the client's circumstances are unknown, the festive housewarming Hickman photographed in 1956 for a Mr. Green

suggests the significance of one family's move (plate 15). Sadly, for every step up, the black community knew of another family slipping down the economic scale. Hickman found what seems to have been a single-parent family being evicted from a housing project in February 1956 (plate 68). Standing on the curb with their belongings, they stare grimly at the photographer.

On newspaper assignments, R. C. Hickman frequently photographed similar disruptions in the lives of his subjects. Children left homeless by fire (plate 16), motor vehicle accidents, funerals (plate 57)—all such were recorded in the *Star Post* if they involved local blacks. Hickman also featured key black newsmakers in his own section, "Photographer's Beat," in the 1950s.

By 1961, activists' pressure on the white business and government leaders of Dallas persuaded the school board to begin implementing public school desegregation. The board insisted that the process begin piecemeal, with selected black first-graders being allowed to attend only a few white schools. To insure that children would not be the first to carry the perceived "weight" of social change, several key restaurateurs and store owners decided to allow integration to begin in their businesses that summer.

The *Star Post* sent Hickman and reporters to record the opening scenes of Dallas's racial integration. Their coverage might have continued much longer but for the death that same year of Dr. L. G. Pinkston, the paper's majority stockholder. Dr. Pinkston had been one of Dallas's few black millionaires and had held an important place in the black community. He founded the first Dallas medical clinic for blacks, because they could not get care at the white-owned hospitals. In addition, he shared his wealth with less fortunate members of the community by turning his farm into a camp for disadvantaged black youth during the summer (plates 43–47). After his death, the remaining directors were unable to sustain the *Star Post*'s financial stability. When the

newspaper closed in mid-1962, Hickman found himself out of work. For nearly a year, he fell back on commercial photography assignments. Then, in the summer of 1963, a friend who knew of his sales and marketing competence contacted Hickman.

Roosevelt Johnson of the Urban League told him that Skillern's Drug Stores had made a commitment to place stores in black residential areas and to recruit blacks to manage several of them. The league put Hickman in touch with company officials, who offered him one year of training to become a store manager. Though he preferred a less-structured work schedule than Skillern's required, Hickman discussed the offer with his wife Ruth. She persuaded him that this opportunity would be worth an adjustment in his hours.

Upon completing the training, R. C. moved into management and succeeded in boosting sales for Skillern's. He recalls that his photographic experience proved especially valuable when customers asked advice about film or camera settings. He also enjoyed training employees in retail service. At Skillern's, Hickman represented the quickened pace of hiring and promoting Dallas African Americans during a period when the city's racial tensions were high. President John Kennedy's assassination in Dallas had exacerbated an already volatile atmosphere there.

Manpower-training programs such as the one at Skillern's followed a national corporate trend in the 1960s. Young blacks and others who demonstrated a will to work, but who lacked adequate employment skills, were able to benefit from new government and industry collaborations. Rev. Leon Sullivan's Philadelphia-based Opportunities Industrialization Center (OIC) provided a significant model for large-scale urban work-training programs. Sullivan's group emphasized three principles: training should be developed with the community it served, it should prepare applicants for entry-level positions that led to better jobs, and it should include attitudinal preparation for the workplace (plate 17).

Dallas minister Rev. H. Rhett James, an acquaintance of Sullivan, decided to adapt the OIC program to address the needs of Dallas's unemployed. He took this idea to the Dallas Citizens Council, composed of powerful business leaders. Several council members helped form a community action committee in 1965 to document the need for job training and to apply for government start-up funds. James gathered community volunteers to clean up a donated building. Lone Star Gas and Dallas Power and Light provided free utilities in the first year of the pilot program. Later, major companies such as Arco, Frito-Lay, and Republic Bank assisted James in obtaining government grants for a fuller OIC program, including job placement for graduates. In 1967, the OIC training was expanded to nine classes, with 320 trainees.

In that year, J. D. Hall, a longtime friend of Ruth Hickman, asked R. C. Hickman to join the faculty at OIC. The center's staff had contacted major Dallas stores to ensure employment for graduates of the OIC retail sales training program. Considering Hickman "a natural-born salesman," Hall chose him as a mentor for young people wanting to learn sales skills.[8] Hickman accepted the teaching position and worked part-time at OIC for nine years. Just as he had tutored newsboys, Hickman successfully communicated business ethics and sales techniques to young adults, stressing the importance of customer service. Scores of trainees studied under him and went on to apply their skills in Dallas-area retailing.

Although Hickman was proud of this educational work, it paid too little to support his life-style, and despite Ruth Hickman's salary as a supervisor of younger teachers in the Dallas public schools he sought other means to increase the family income. Having left Skillern's in 1968, he had been working in real estate. In the mid-1970s R. C. decided to develop a janitorial

[8] J. D. Hall to Sherilyn Brandenstein, Aug. 10, 1990, interview.

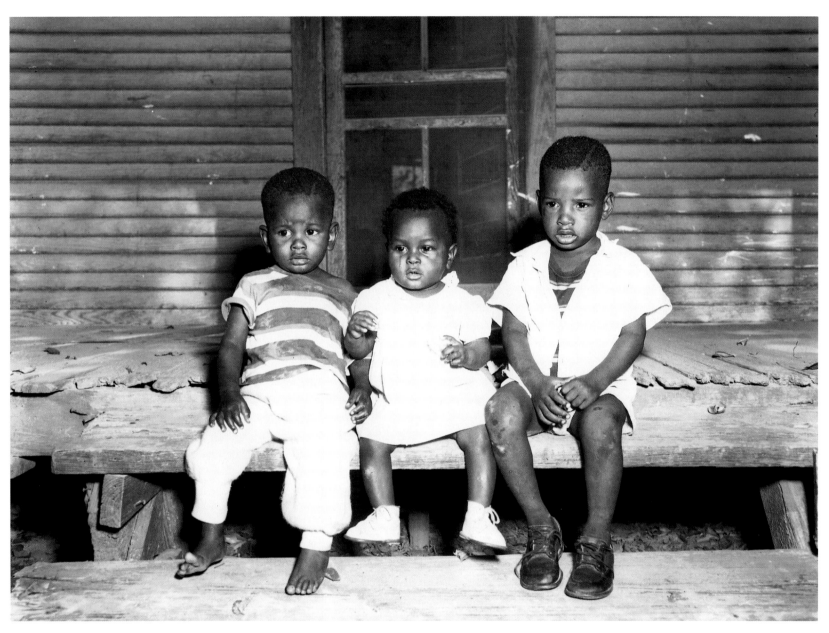

"They were just hopeless. I said, 'I'm going to take their picture to tell about the fire.' I don't know their names. That was not important. It was that they had been burned out of their home."

16. After the fire, 1954.

17. Dallas Opportunities Industrialization Center. Clerk typing/retail sales class, 1969.

service. Meanwhile, he continued managing several residential properties.

As for Hickman's photography business, it had dwindled while he was at Skillern's, leaving former clients to wonder aloud why he had abandoned the photographic career that had so satisfied him and them. In truth, Hickman seldom was content to remain with enterprises that no longer challenged him. Repeatedly he sought out fresh business ventures. Each one offered "a new challenge and a new opportunity for added financial success," he states. If photography had been his challenge in the postwar decades, gradually other interests replaced it.

Besides supervising a janitorial service in the 1970s, Hickman also managed bowling alleys in Dallas and Fort Worth for a time. More recently, he has assisted J. D. Hall with Decorative Interiors, Inc., an Oak Cliff carpeting business. He remains active in church and community organizations, including the Cotillion Idlewild Club, the Pylon Salesmanship Club, and the Dallas branch of the NAACP. Though he turned seventy-one in 1993, he remarks, "I do not consider myself retired."

R. C. Hickman's work reveals a photographer aware of the broad community context within which individuals survive, grow, and understand themselves. Indeed, Hickman's own life was shaped in the crucible of family and community. His news photography, though commercially motivated, was a conscious contribution to social change generally and black empowerment specifically. Hickman the portraitist had a keen awareness of how visual representation could enhance the self-image of his subjects in the community. He was capable of composing and shooting quickly if necessary. Yet, when given the choice, he carefully attended to the alignment and attire of the groups he photographed, recognizing that customers had the final say.

Fortunately, Hickman took as much care in preserving his negatives as he did in gathering images of African Americans. Because of his photographic training, Hickman had learned to date his negatives and to store them properly. Also, he was a "pack rat" by nature, seldom throwing anything away. He stored his photographic negatives in his home until 1984, when historians learned of his work for the NAACP. While preparing a doctoral dissertation on the NAACP's history in Texas, Michael Gillette of the Lyndon Baines Johnson Library and Museum in Austin, Texas, learned that the former NAACP photographer was still living in Dallas. Gillette and Dr. Don E. Carleton, director of the Center for American History at the University of Texas at Austin, decided to visit Hickman and look at his collection.

When Carleton viewed Hickman's collection, he immediately recognized its value as a visual resource documenting African American history and social and urban studies, and he invited R. C. to donate his collection to the Center for American History. Hickman agreed, and his negatives were transferred there in stages between 1985 and 1987.

The University of Texas celebrated the acquisition in February 1987 with a photographic exhibit titled Black Dallas in the 1950s: Photographs from the R. C. Hickman Archive. In October, the Dallas Historical Society sponsored the exhibit at Fair Park. In the summer of 1988, Congressman Martin Frost arranged for the exhibit to be shown at the FirstRepublic Bank in the Oak Cliff section of Dallas. The resulting publicity brought national attention to and interest in Hickman's work. The Library of Congress has since included his photographs in an exhibit, and Marianne Fulton features a Hickman image in *Eyes of Time: Photojournalism in America*. Such recognition appropriately places Hickman's work within American social history and journalism history.

Still, his contributions are especially cherished in his own city. He has received honors from the Dallas branch of the NAACP and the Texas Publishers Association. In 1990, the Dallas-Fort Worth Association of Black Communicators (ABC), an organization striving to ensure that mass media companies acknowledge and employ African American sensibilities, honored Hickman for his photographic contributions and his dedication to the association's principles. The honor is a reminder of the particular responsibilities African American communicators find thrust upon them.

Decades after being shot through the lens of his Speed Graphic, R. C. Hickman's photographs have gained added value because so few large photographic collections by blacks in the postwar decade have been preserved. Without such images, Americans could easily forget, or never learn, that black Dallasites, and their homes and clubs and businesses, added much to Texan urban life and history. In cities where Anglo Texans dominated social and economic life, whites long avoided recognizing the resourcefulness, productivity, and diversity of the African American citizenry. In his life and his work R. C. Hickman, photographer, has helped correct that chronic myopia.

"I was there as a guest, but I had my camera. I always had my camera." 18. An evening at Dr. Hughes's house, 1954.

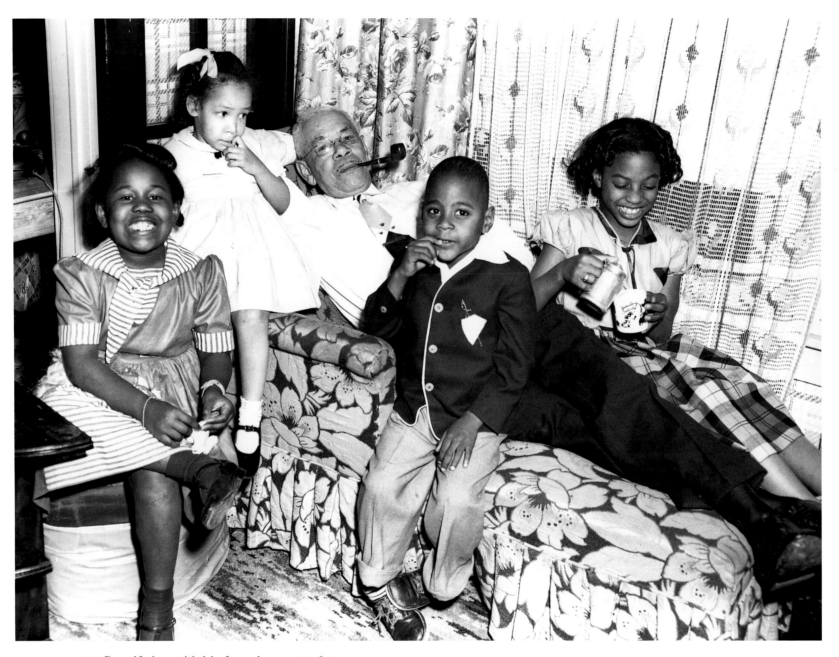

19. Grandfather with his four charges, 1961.

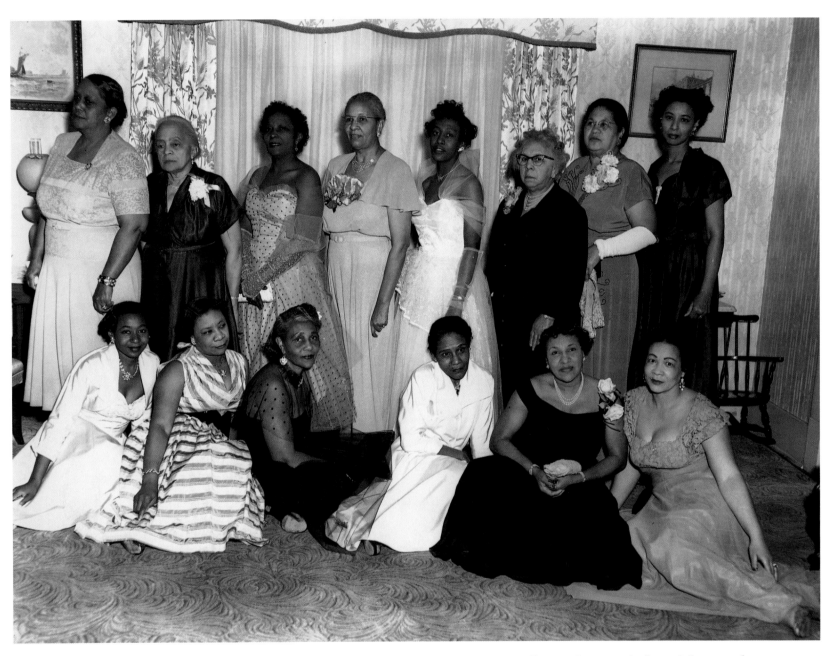

20. Group of women in formal dress, 1961.

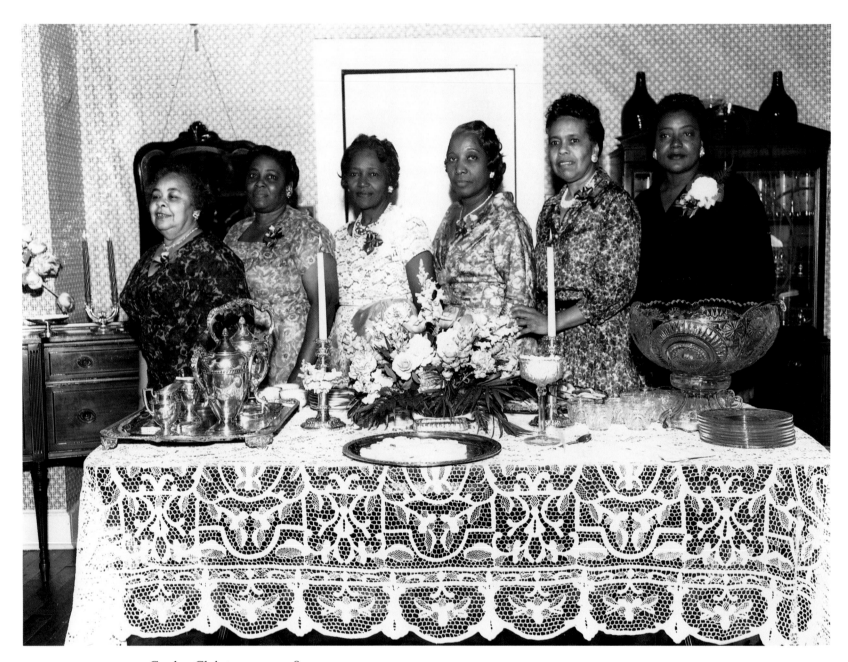

21. Garden Club tea, ca. 1958.

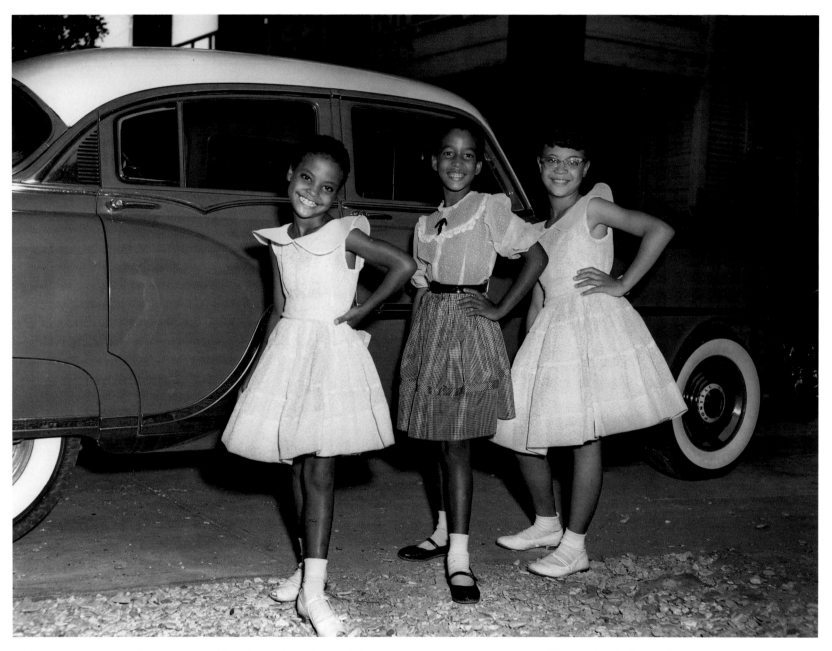

"I just saw them and thought it would make a nice picture. My paper thought so, too, and they ran it."

22. Three girls in front of car, 1958.

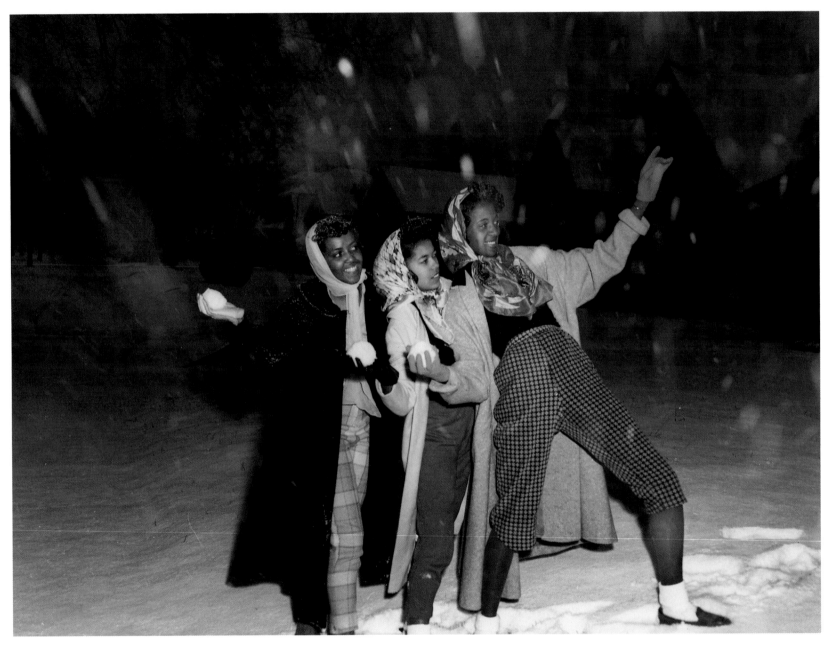

23. Three young women playing in the snow, 1958.

"I shot a lot of photographs on the spur of the moment, because I saw an interesting picture."

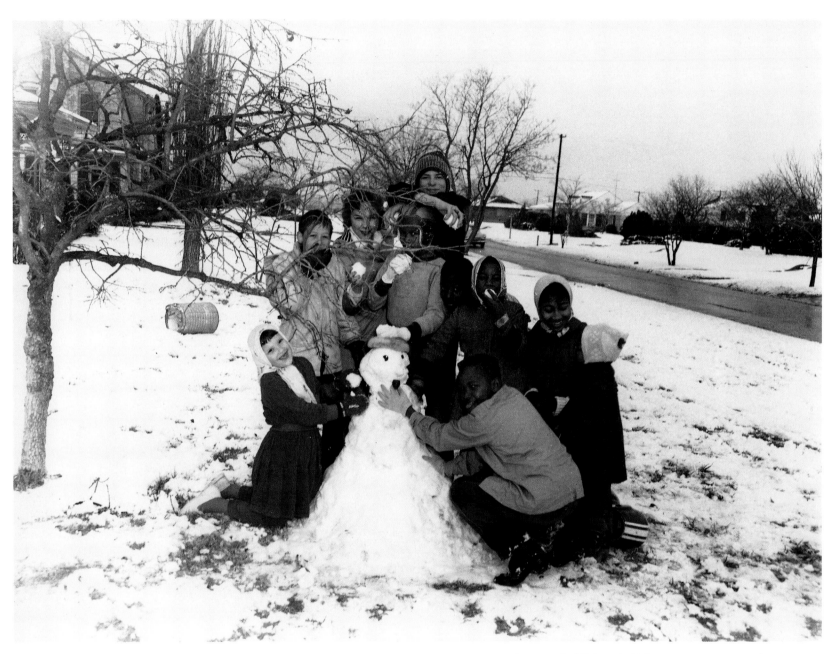

24. Group of children building a snowman, 1961.

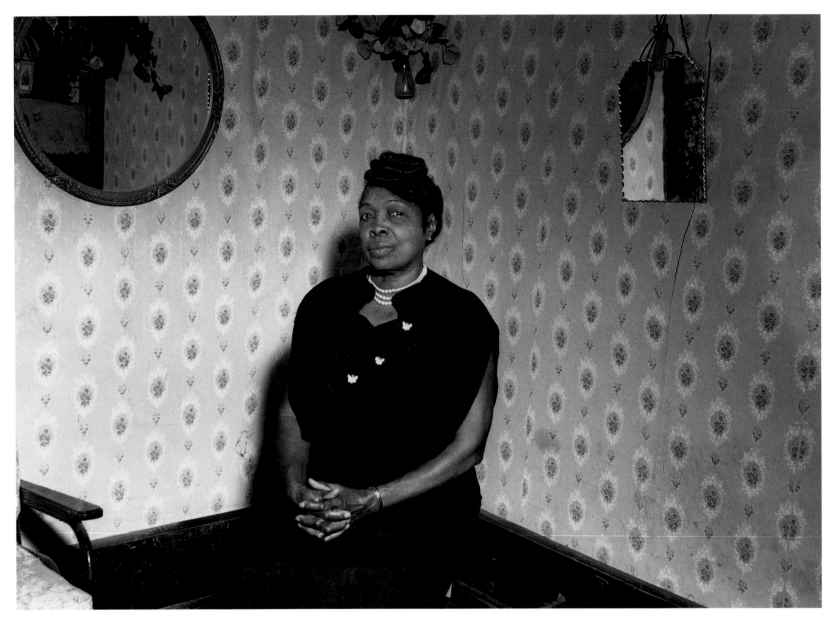

25. Mrs. Prince, 1950.

"I went to Hall Gentry Photographic Studio in downtown Dallas and laid my discharge, which states I worked on photography in the army, on the desk of the manager and asked for a job. He asked if I would like to be a darkroom technician. I worked there several months and I began to understand that I didn't know too much about portraits."

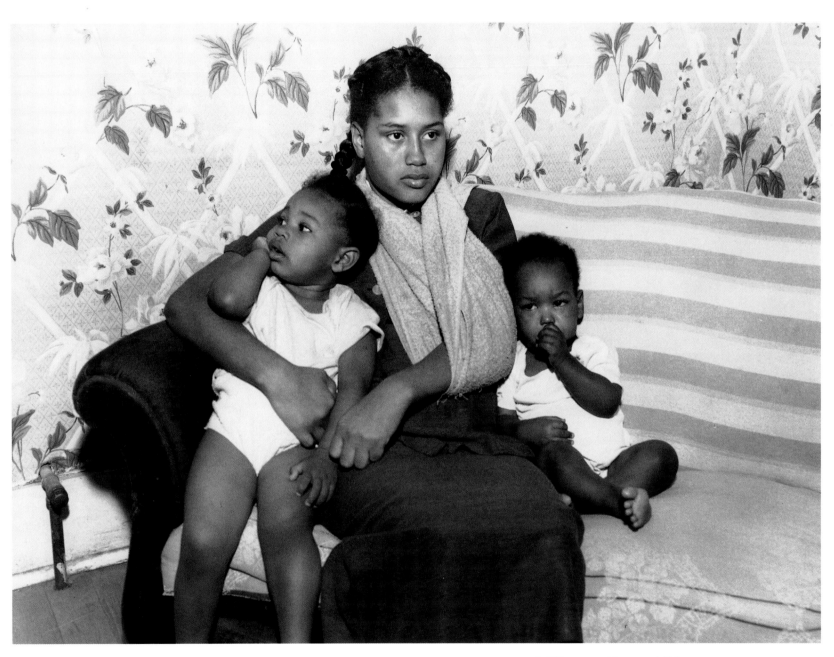

26. Woman with two children, 1957.

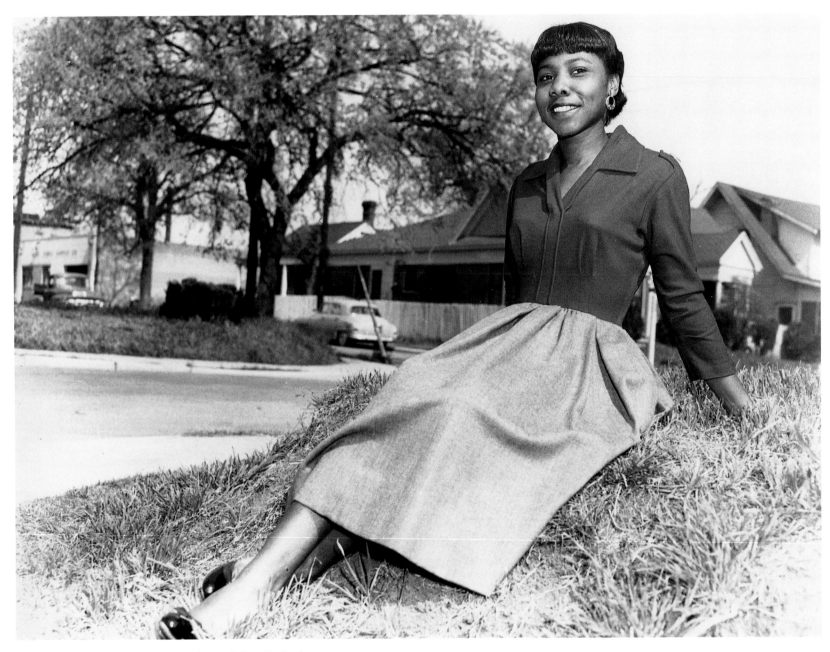

27. Young woman on lawn (Mrs. Parker), 1957.

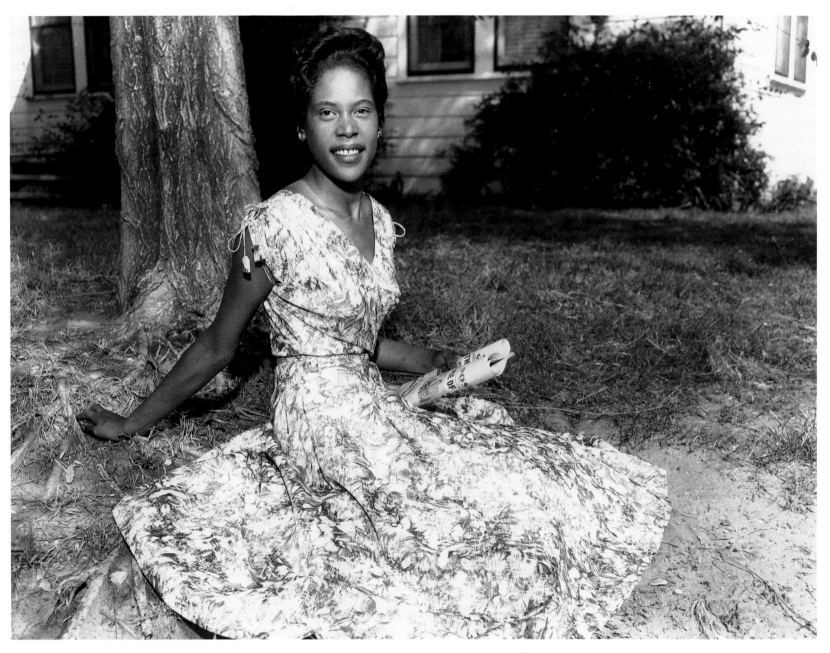

28. Another young woman on lawn, 1957.

29. Miss Beverly, 1953.

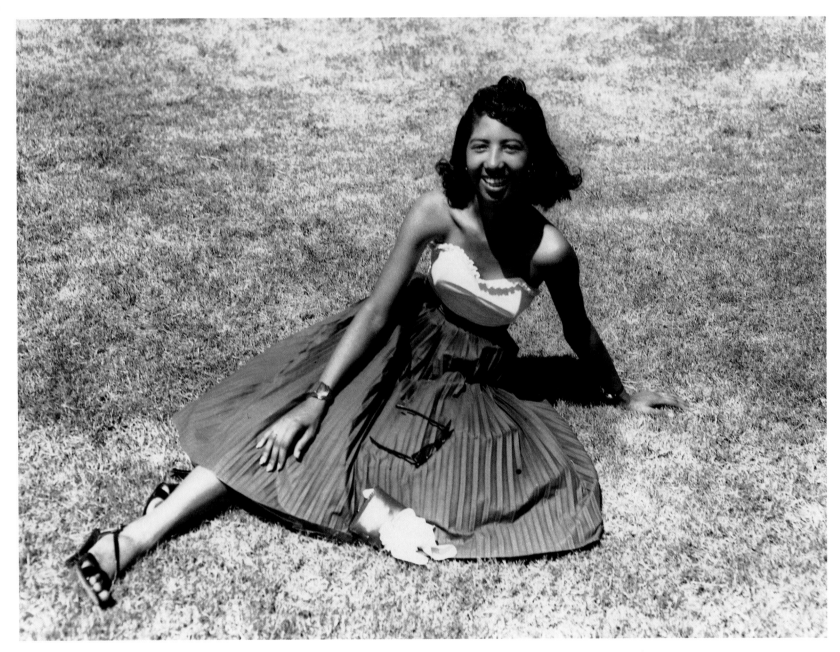

"That's a pretty shot. See the highlights, middle tones, and shadows." 30. Betty on lawn, 1955.

45

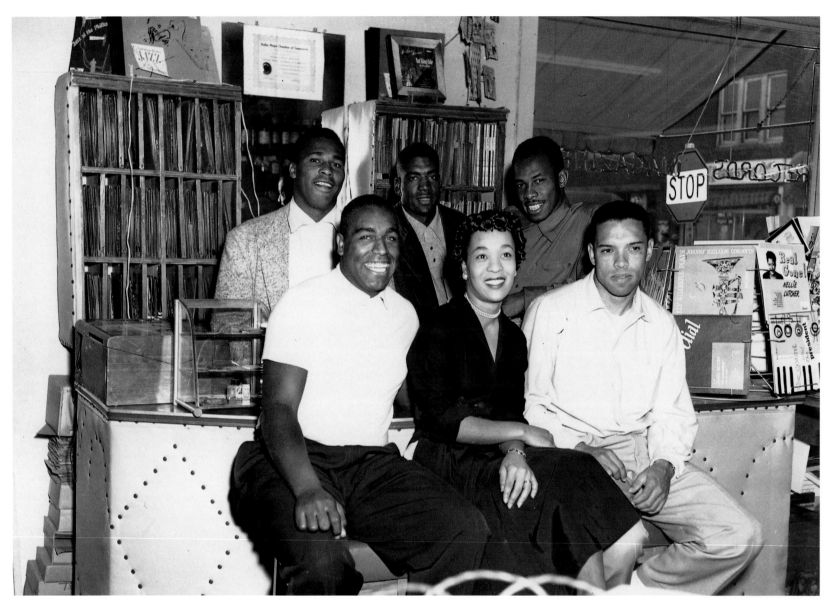

31. Record Shop, 1952.

"Dickie Foster was selling records at a little shop much like this one. Hers was in a corner of Clark's Liquor Store. I told her I wanted her to write a column for the Kansas City *Call* called 'Platter Chatter.' She said she didn't know how to write a column. I said, 'I'll teach you. Those records you are selling are platters, and chatter is talk. Write social news. If you put people's names in the paper, they'll buy a copy, and also read about the top ten records of the week.' So that's what happened. She sold a lot of records and I sold a lot of papers."

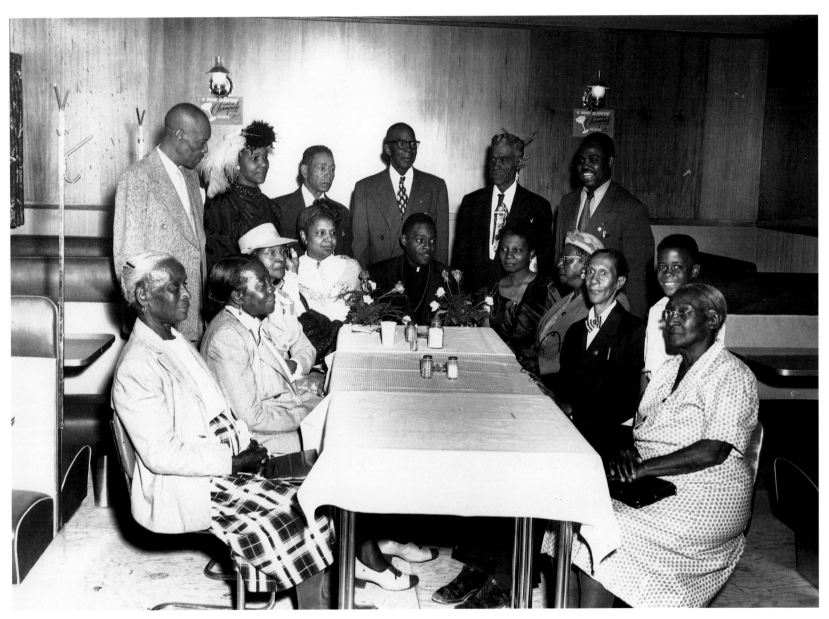

"When I approached Carter Wesley, publisher of the *Express*, for a job, he said he couldn't hire me, but that he would teach me to sell ads and would pay me for any photographs the paper used. I replied, 'I appreciate your giving me a chance.'"

32. Dallas *Express* meeting, 1952.

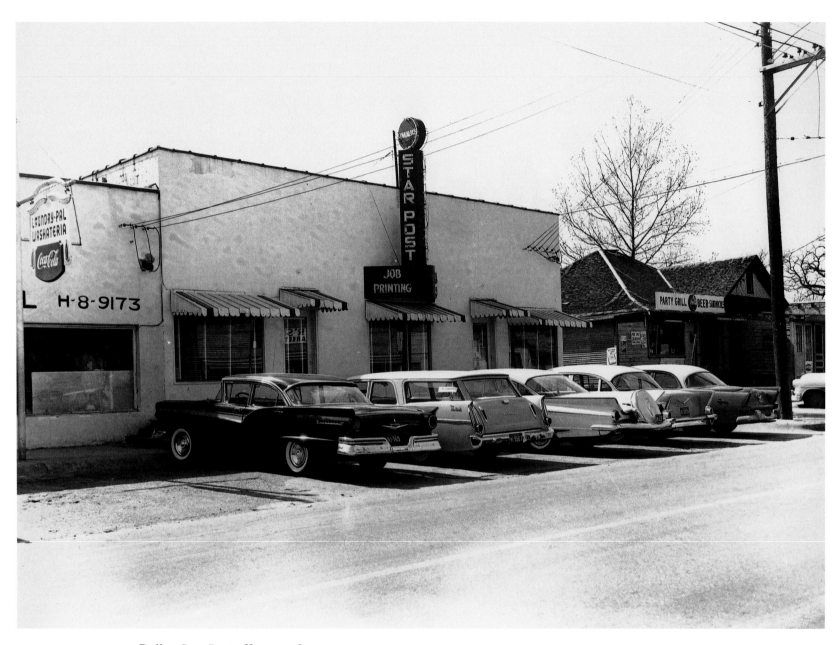

33. Dallas *Star Post* office, 1958.

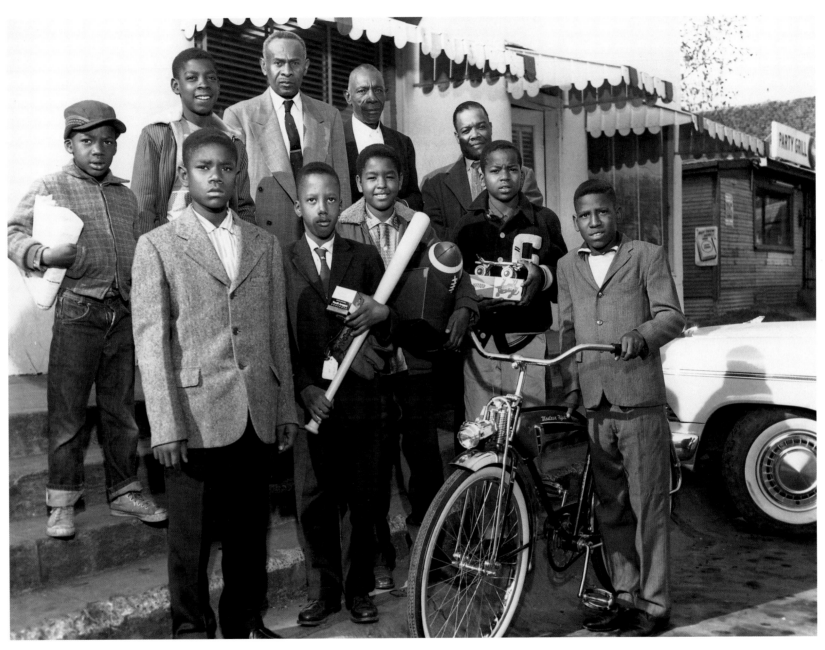

"The Dallas *Star Post* was a hometown-owned weekly newspaper." 34. Group of boys and men in front of *Star Post*, 1958.

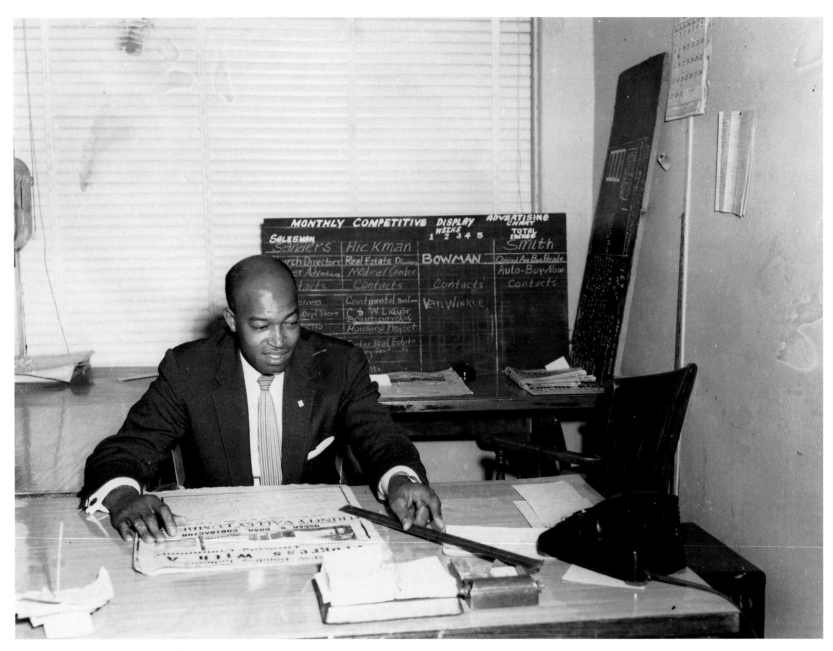

35. R. C. Hickman at desk, 1959.

"I was a busy man. I did three jobs: circulation manager, advertising, and photography."

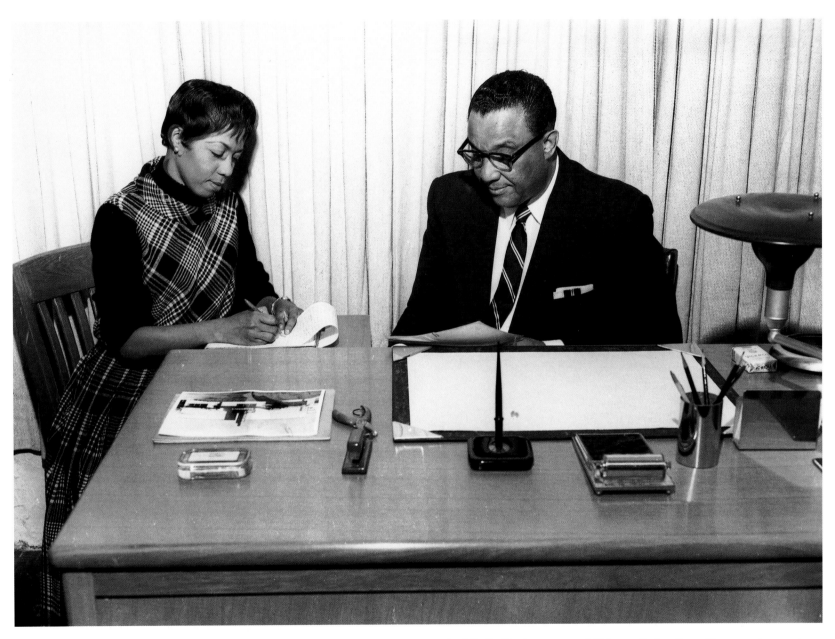

"W. J. Durham was an attorney for the NAACP and he owned half-interest in the newspaper. So you can see how it was easy for him to use me for all the NAACP photograph work and the *Star Post* work."

36. W. J. Durham, copublisher of the *Star Post*, and secretary, 1958.

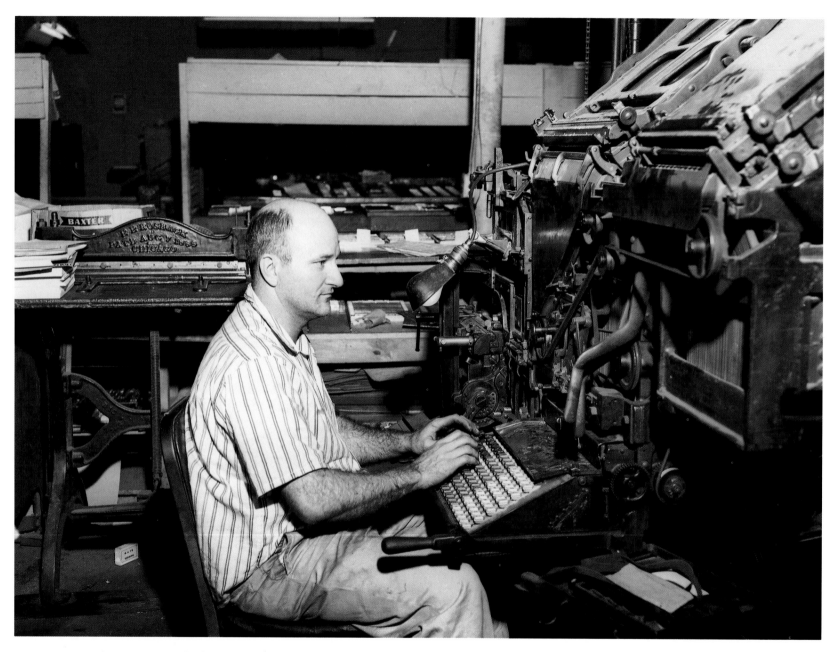

37. Linotypist, *Star Post*, 1959.

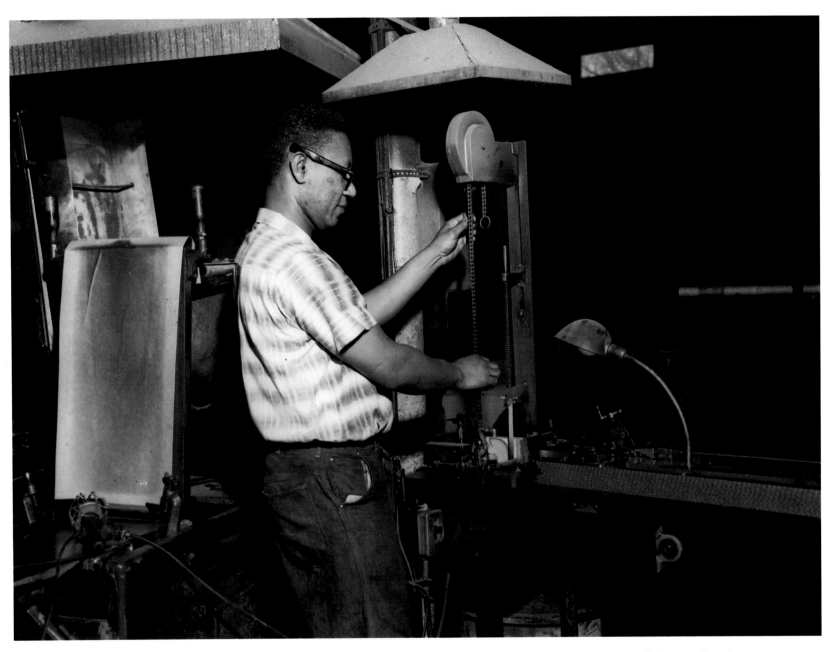

38. Machinist and presser T. O. Love, *Star Post*, 1959.

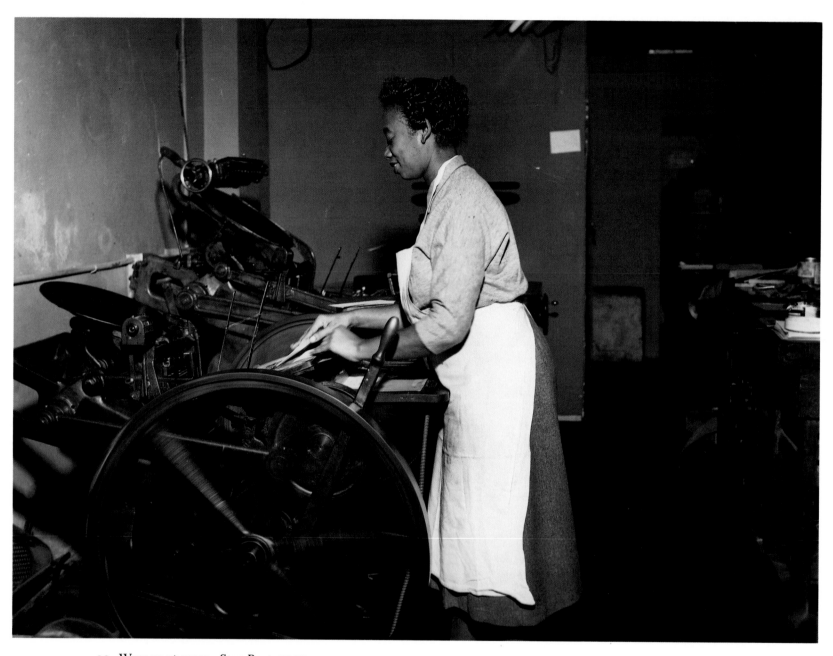

39. Woman at press, *Star Post*, 1959.

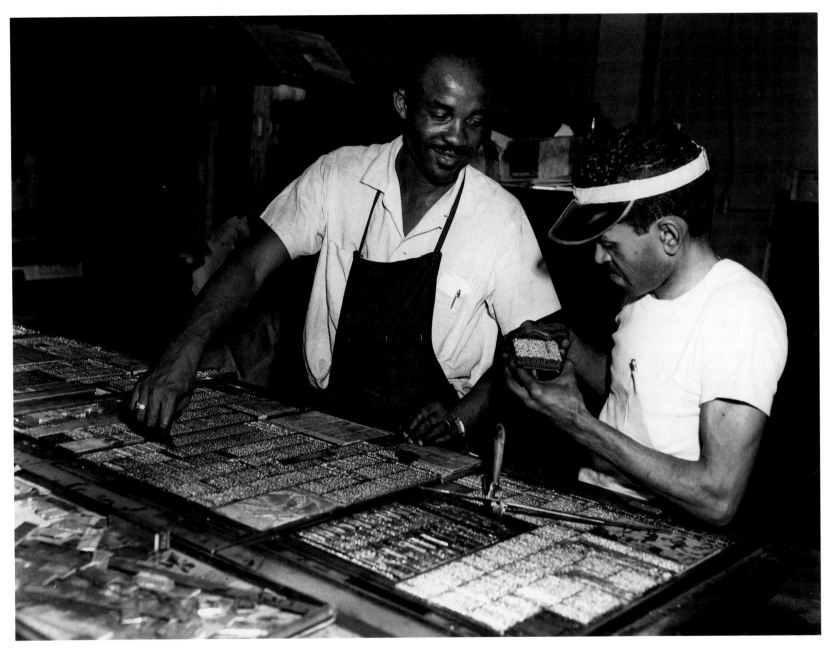

40. Linotypists Howard Trigg and O. A. Branch, *Star Post*, 1959.

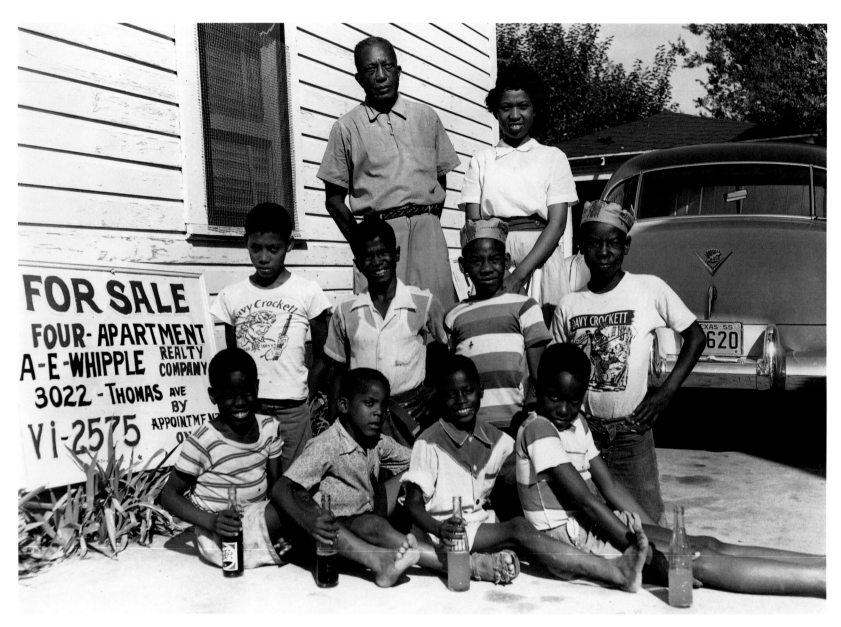

41. Whipple Realty and newscarriers, 1955.

This is a picture of A. E. Whipple, a board member of the *Star Post,* and *Star Post* carriers.

"I told my boys that if they sold the most papers in a week, I would put their picture on the front page of the *Star Post* as 'Man of the Week.' I didn't say 'boy.' I said 'Man of the Week.' Little man."

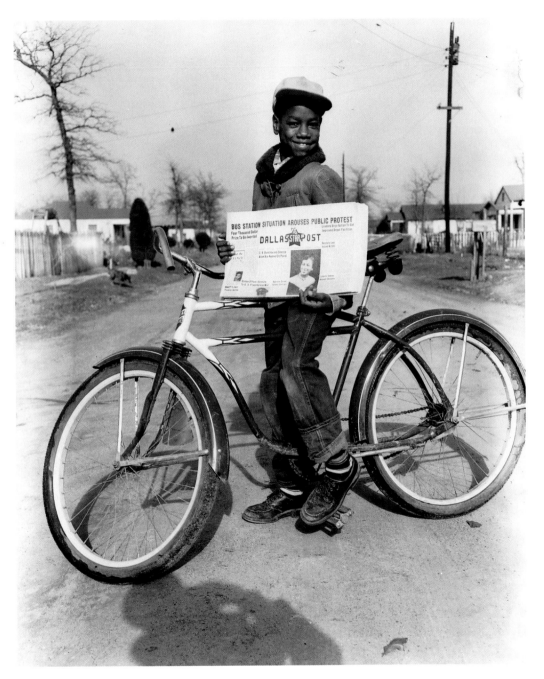

42. Bobbie the newsboy, 1953.

"I would ask them, 'Do you want to make twenty nickels? When you sell twenty papers, you will earn twenty nickels. How much is that?'"

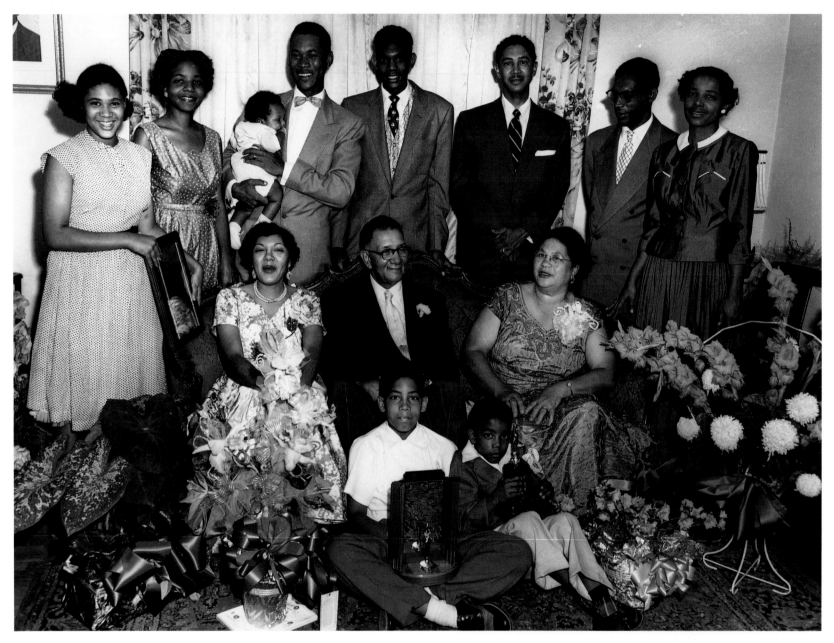

43. Dr. Lee G. Pinkston and family, 1954.

"This book cannot be published without Dr. Pinkston in it. He was a very influential man in black Dallas. And he gave back a lot to his community."

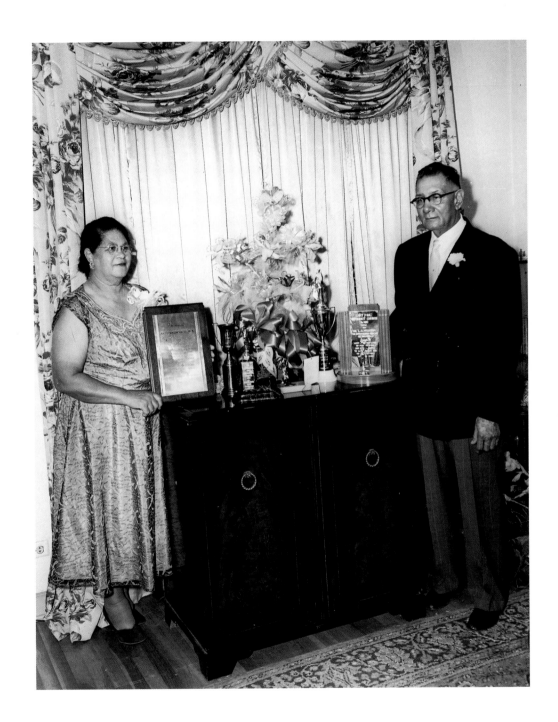

44. Dr. Pinkston and wife, 1954.

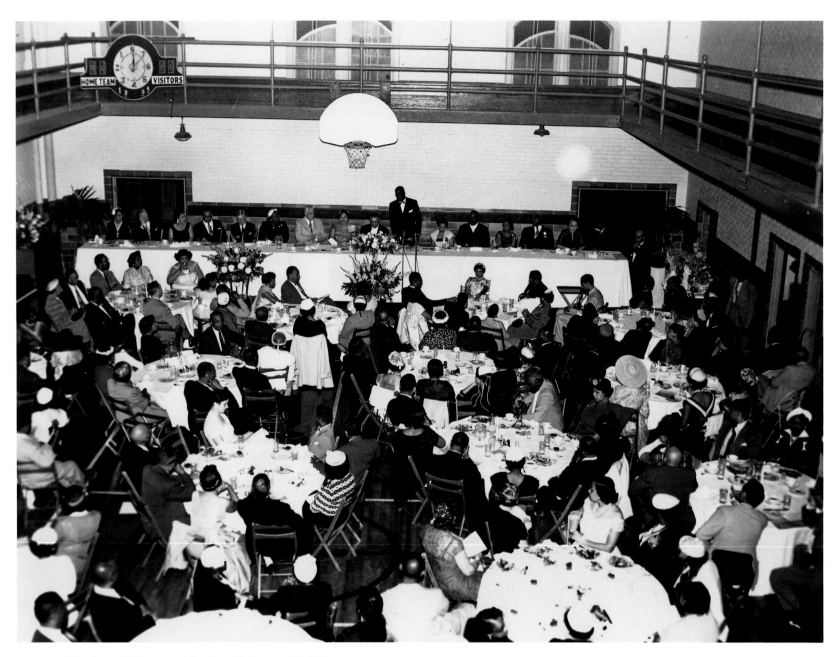

45. Testimonial banquet for Dr. Pinkston, YMCA, 1954.

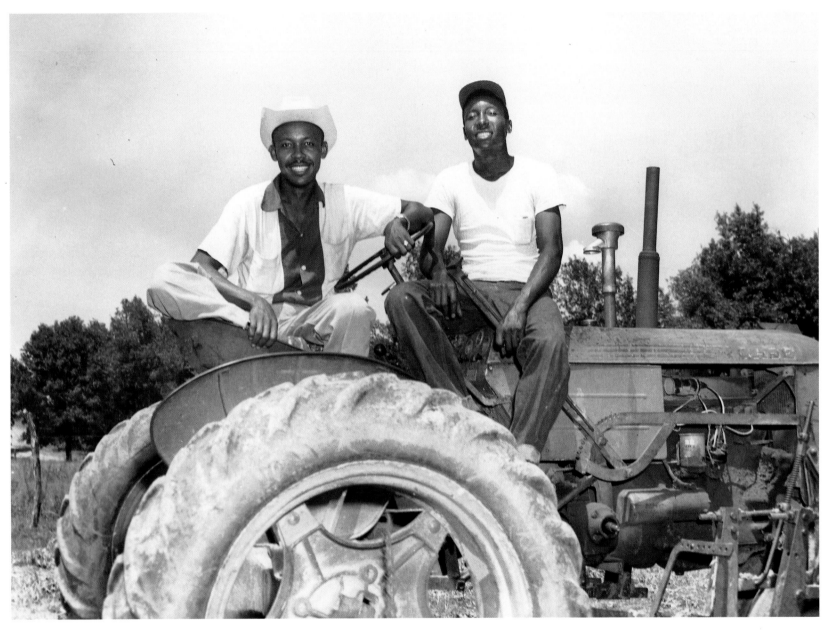

"Dr. Pinkston was one of the few millionaires in the black community. In the summers he opened his farm to inner-city kids so that they could get away from the concrete."

46. Working Dr. Lee Pinkston's farm, 1955.

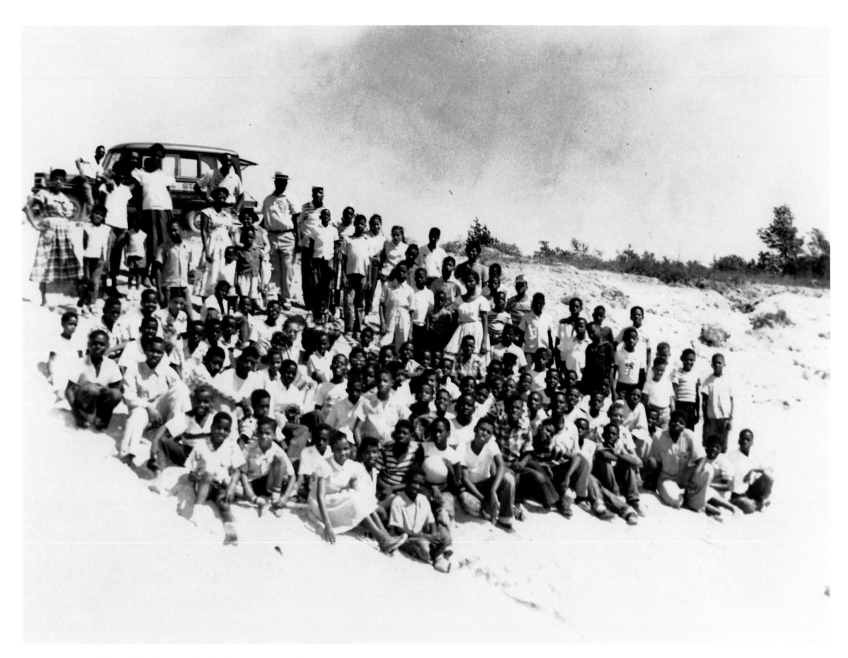

47. Camp Pinkston picnic for newscarriers, 1950.

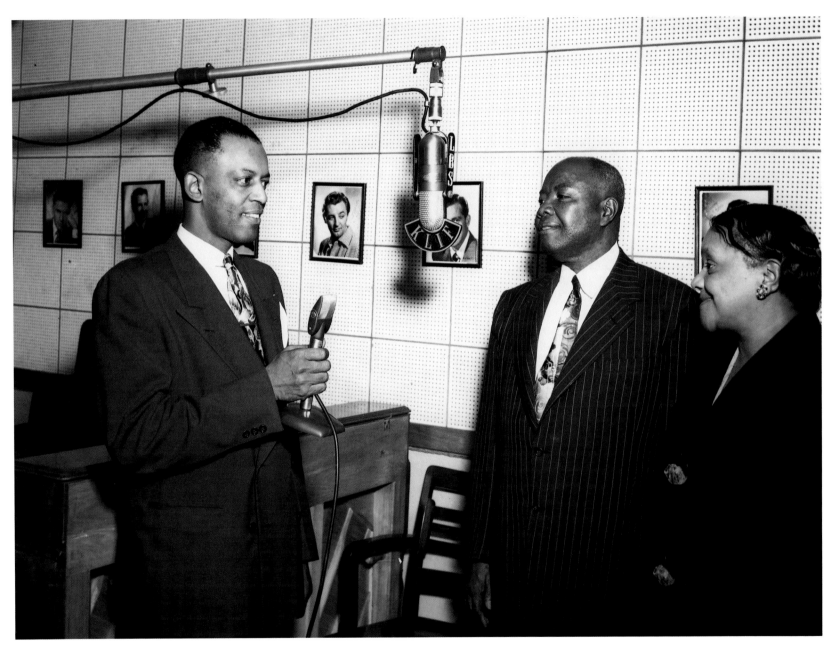

48. Mr. and Mrs. Johnson at KLIF, 1950.

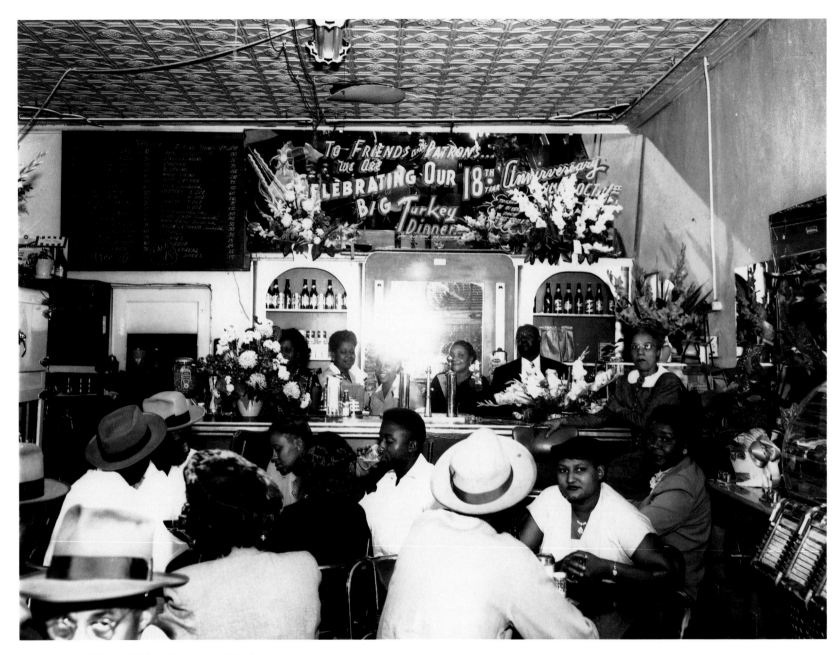

49. Mr. and Mrs. Johnson at their restaurant, 1950.

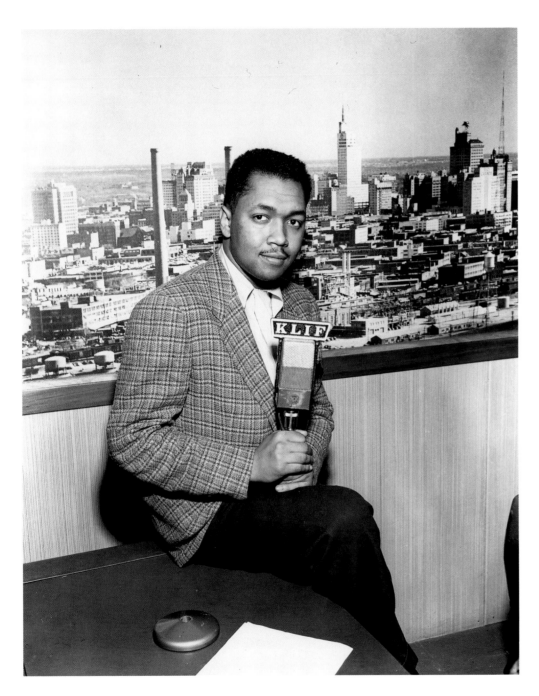

50. Jim Randolph, KLIF disc jockey, 1954.

"I shot that at the studio and got the Dallas skyline in the background."

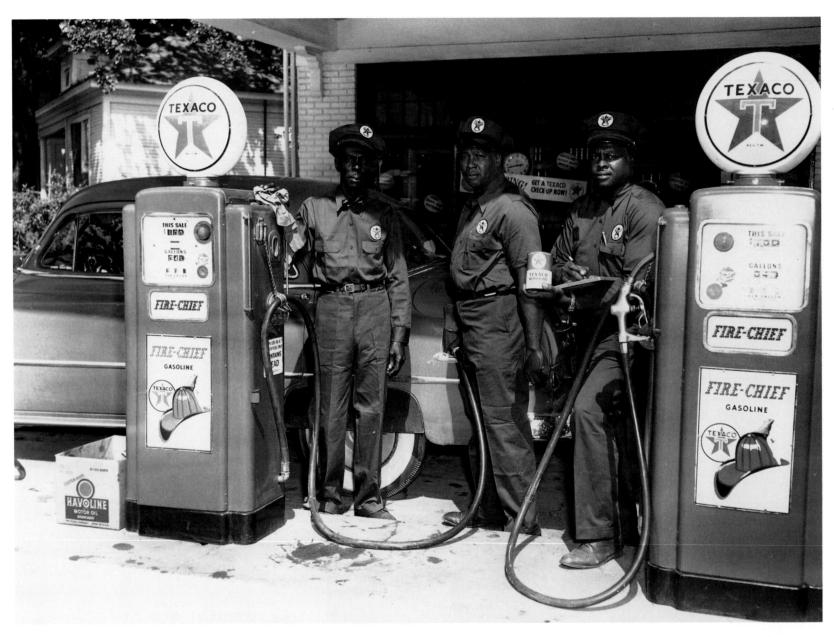

51. Mac's Texaco, 1953.

"This was in South Dallas on a very popular street. Mac was the first black man to have a service station. At that time they were not giving franchises to black people."

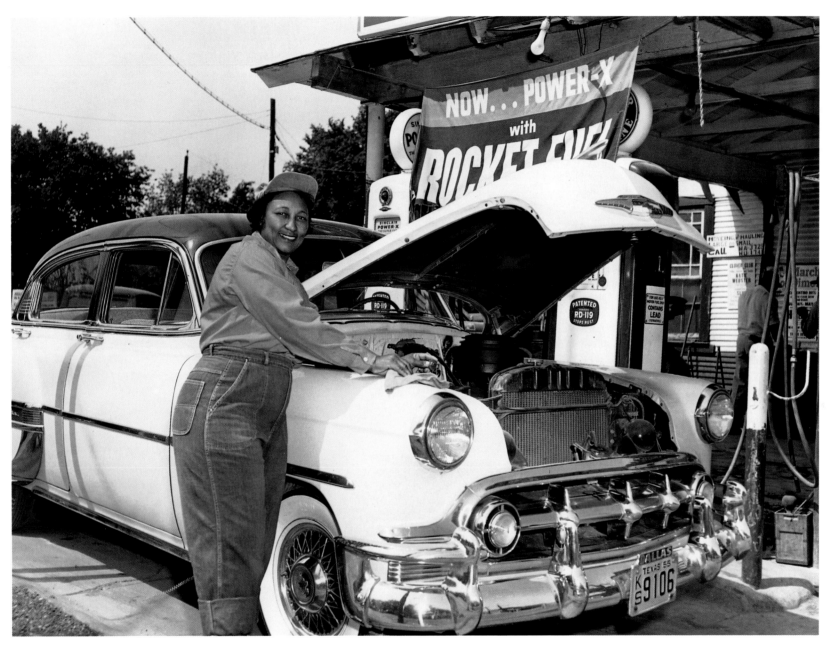

52. Service station owner Annie Carr Mercer, 1955.

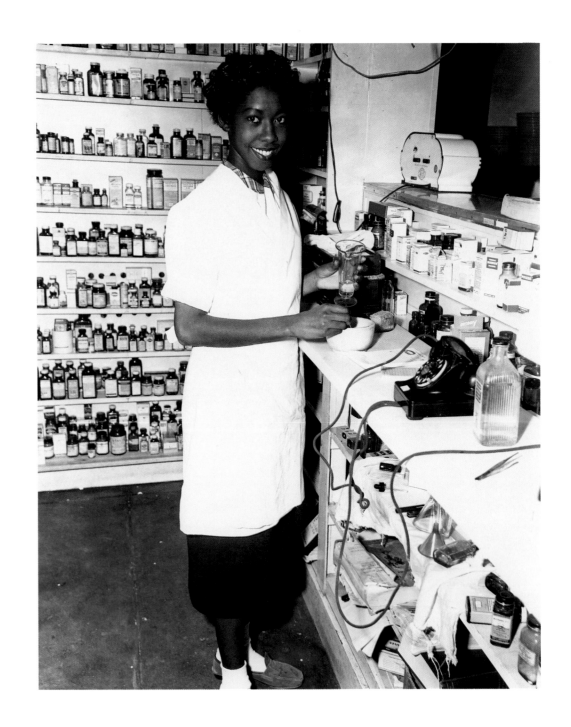

53. Thrifty Drug pharmacist, 1952.

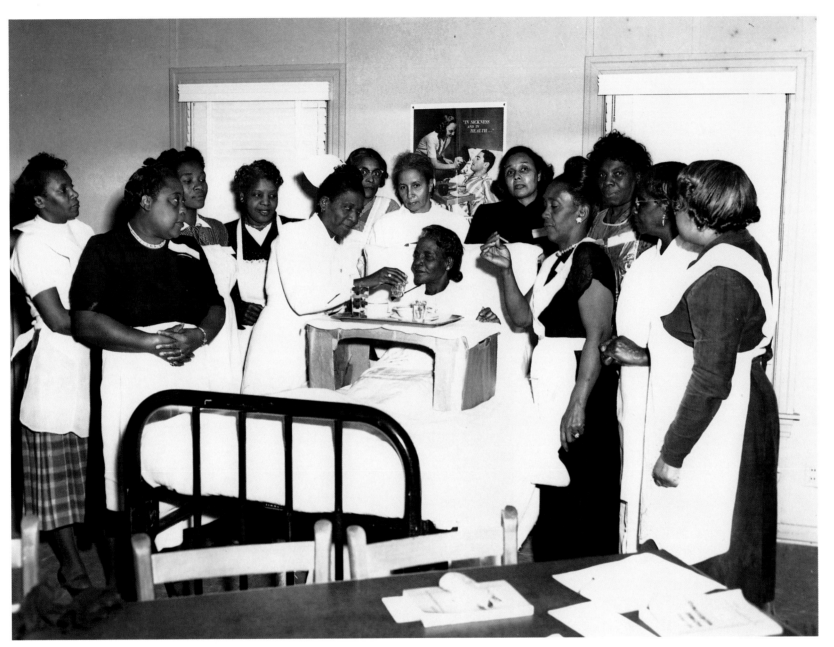

54. Red Cross nurse's class, 1953.

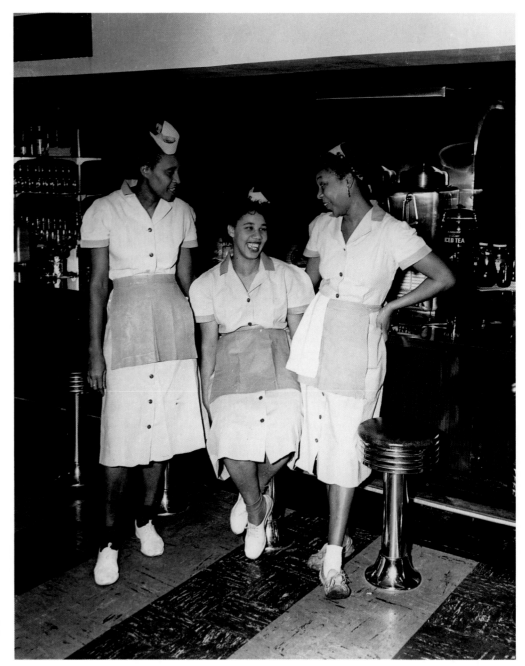

55. The girls of the Aristocrat, 1953.

"Sometimes I see a photograph when I look at a scene or at people. It's like I'm looking through the eyes of my camera instead of my own eyes."

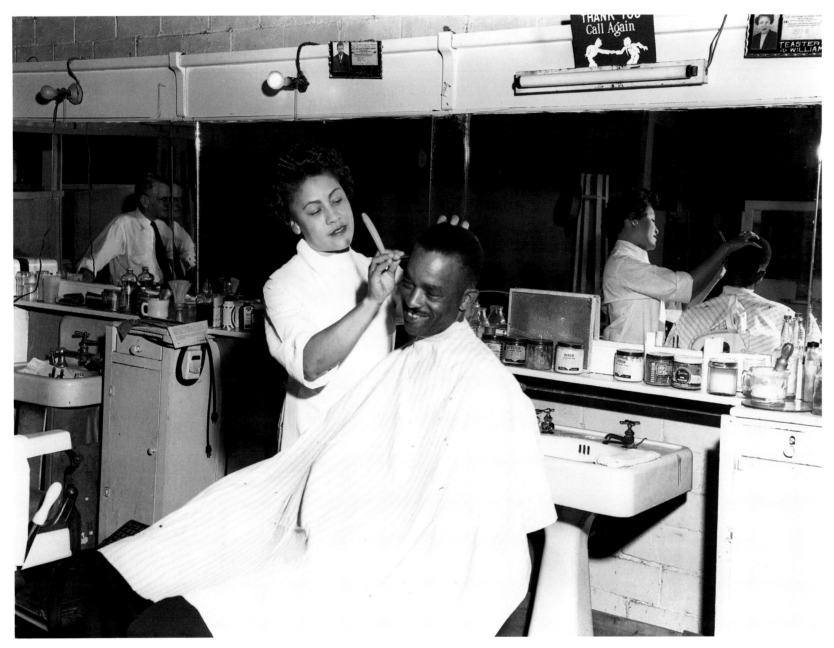

"Many times there was no reporter sent with me on assignment. My picture had to tell the story."

56. Woman barber, 1955.

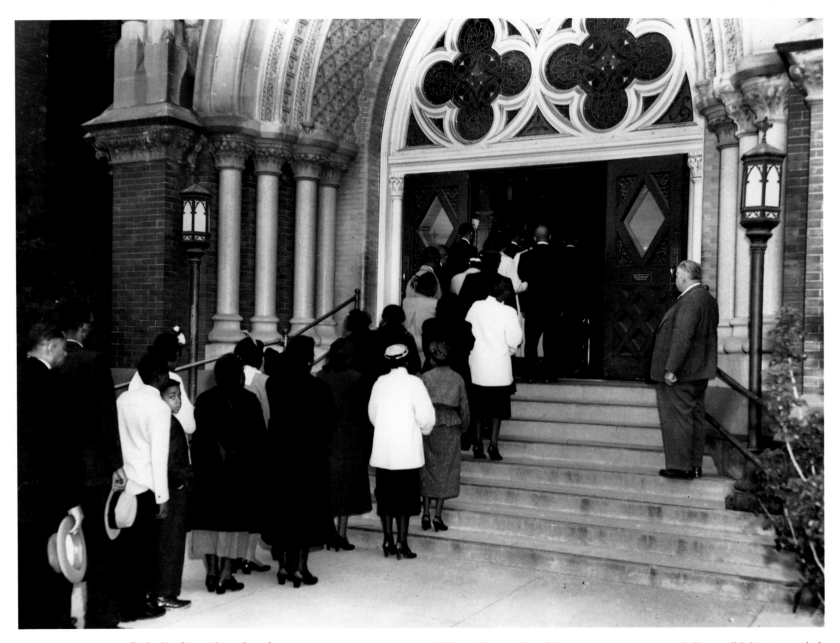

57. Catholic funeral at church, 1954.

"According to the white newspaper, we weren't born, didn't get married, or die. Our pictures did not appear in their paper and very few news items about us appeared in their paper."

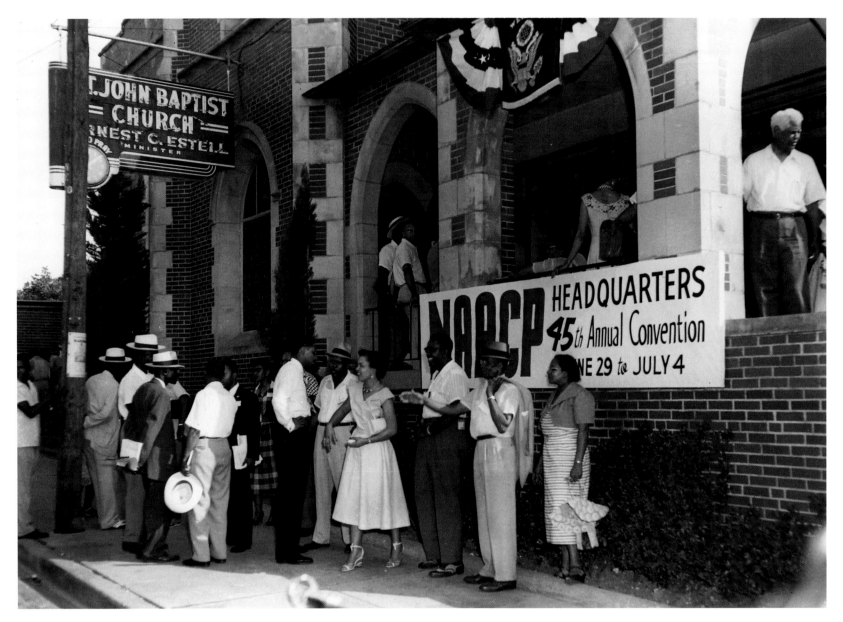

"My pastor, Rev. E. C. Estell, said, 'Mr. Hickman, I want you to get with the *Star Post*. We need your services for your own hometown newspaper.' The paper had just come to Dallas about six months earlier and Estell was on the board of directors."

58. St. John Missionary Baptist Church, 1954.

"The church was a powerful influence."

59. Church gathering at private home, 1954.

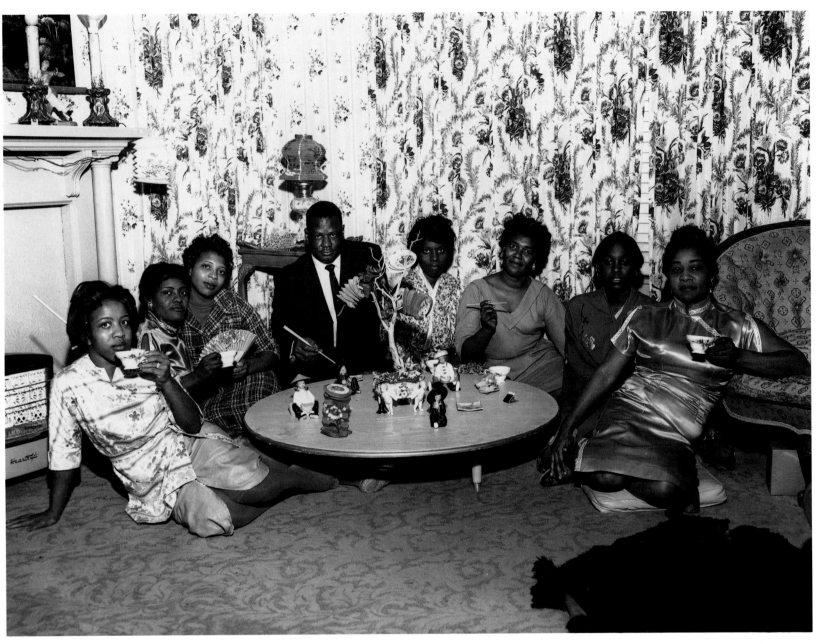

60. China tea, Forest Avenue Baptist Church, 1961.

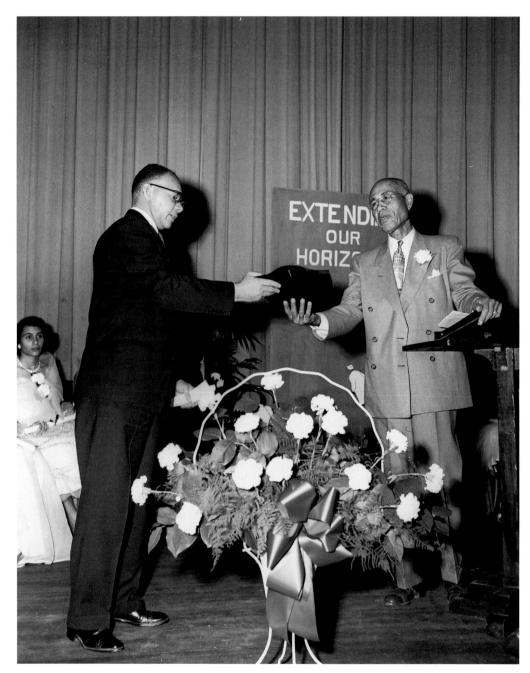

61. "Extending Our Horizons" award: Coach
Edmunds gets plaque, 1954.

"We were [viewed as] second-class citizens and we
had to prove that we were not."

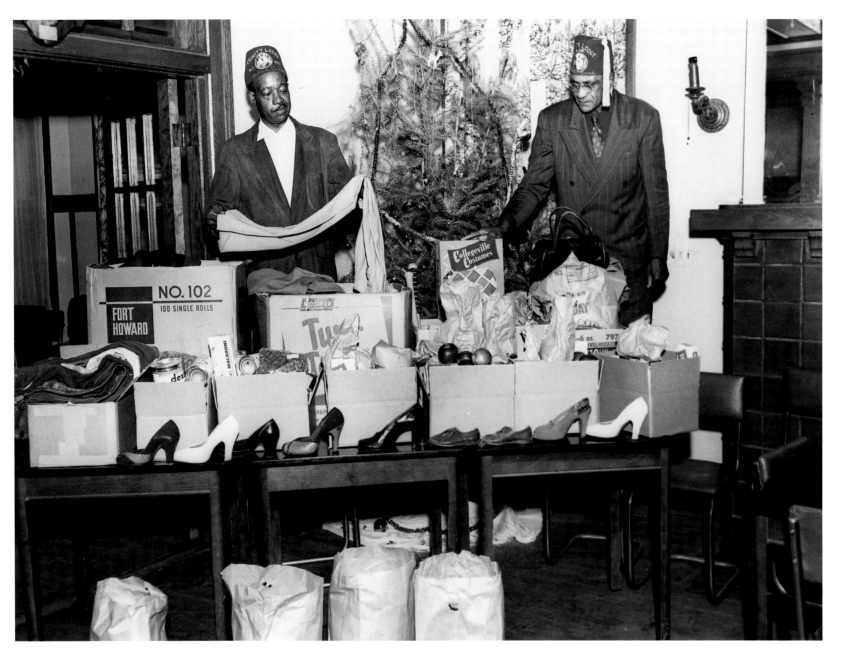

62. Elks with Christmas gifts, 1957.

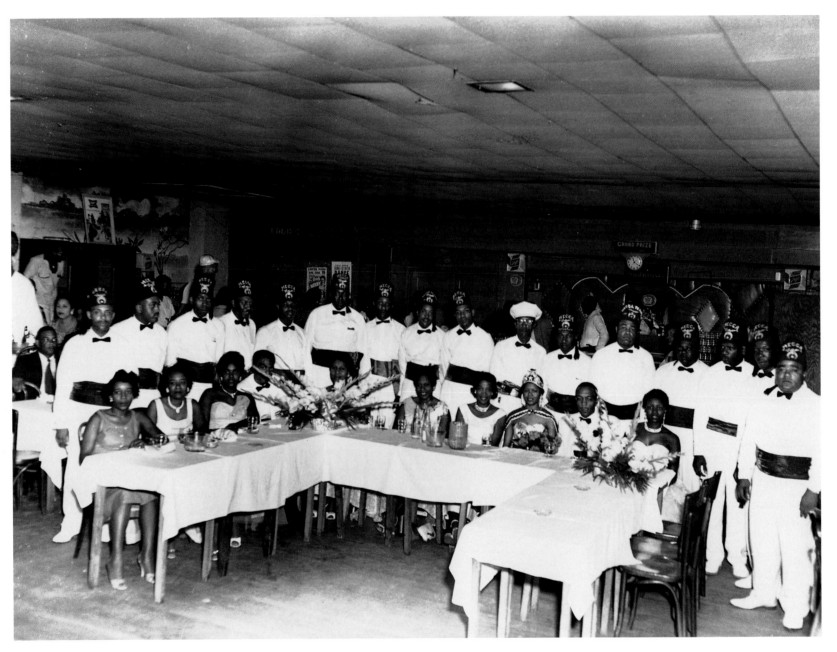

63. Shriners, 1957.

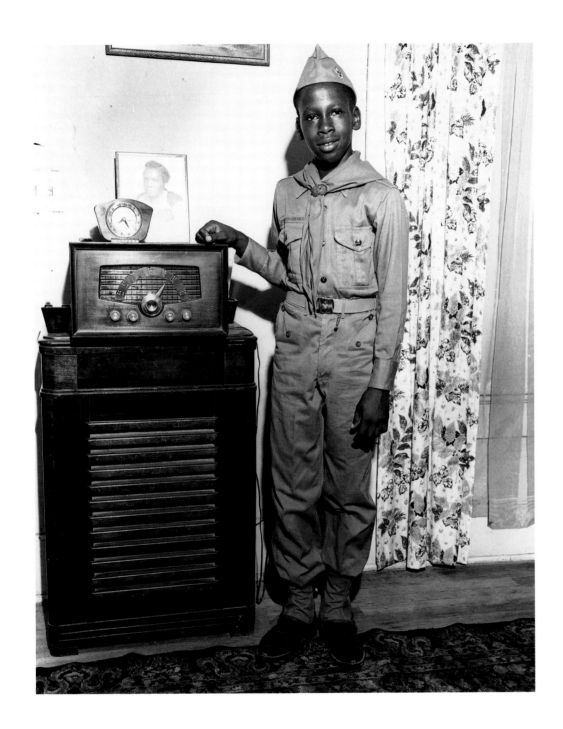

64. Boy Scout, 1957.

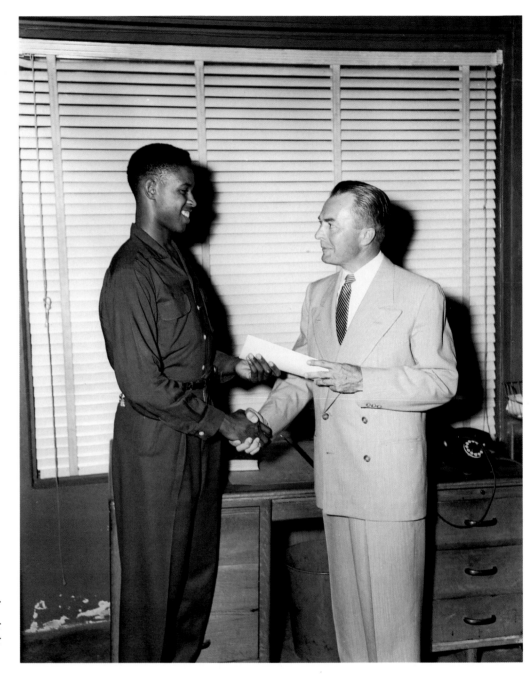

65. High school boy receives scholarship, 1954.

"We have come a long way, but certainly not far enough. We're still struggling for equal education for our children."

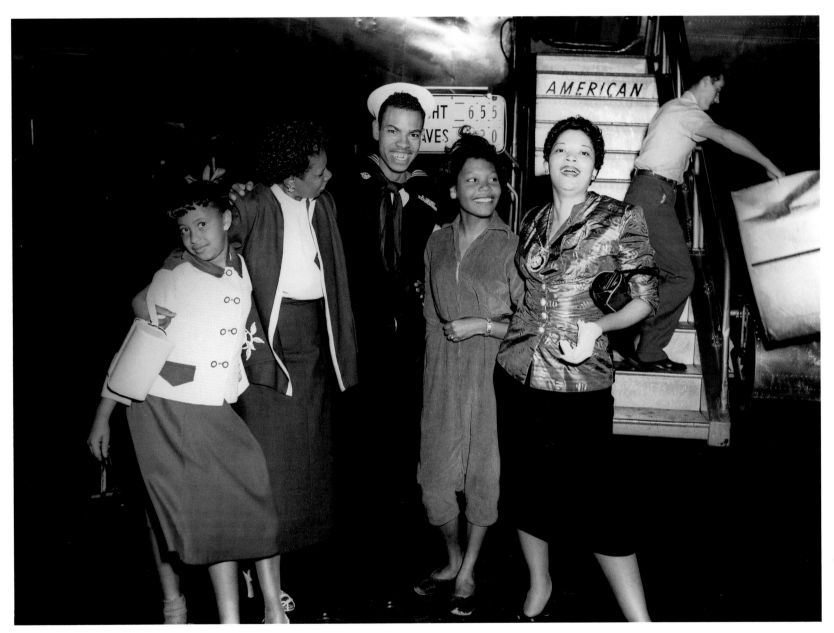

"I was in the service between 1942 and 1945 and the army at that time was segregated. There were no white guys in my battalion except, of course, the officers."

66. Mrs. Murray's son flies home, 1954.

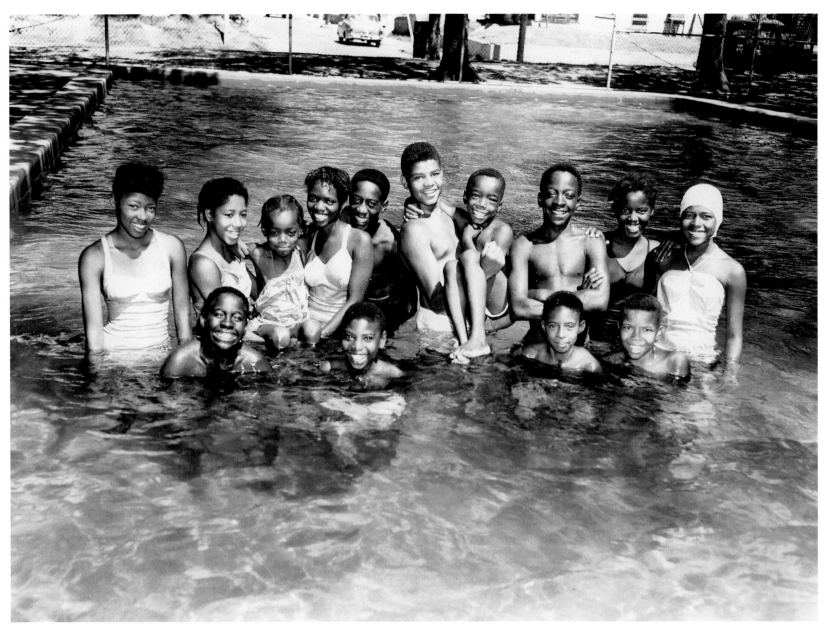

67. Exline Park, 1955.

"This was really news. It was the first summer blacks could swim in a Dallas city pool. The kids were thrilled to death. Before this, blacks could not swim in public pools. We were not part of the public."

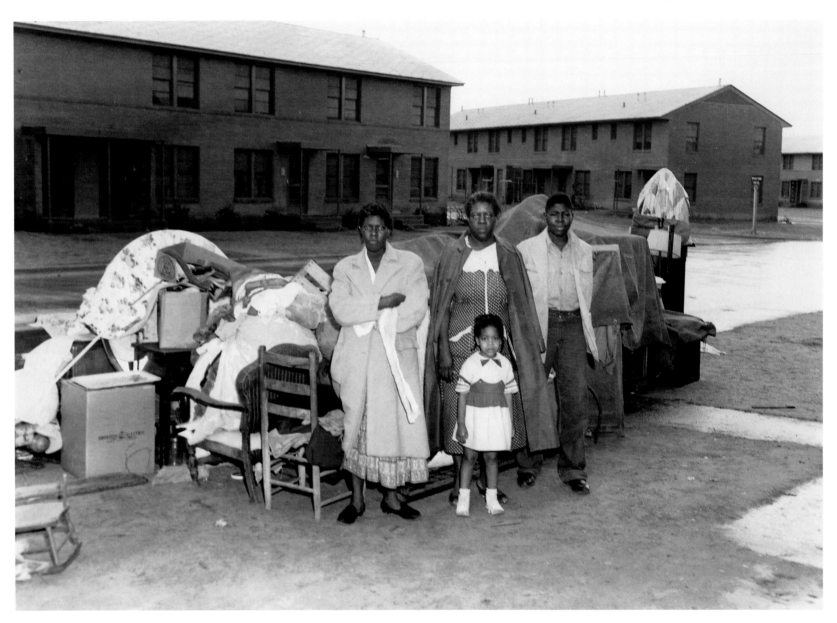

"When something happened to black people, that was news to us. That helped sell papers. It is just like when a black man rapes a white woman—you know that is going to be in the white press. But nothing like this would ever be in the white papers."

68. Eviction, 1956.

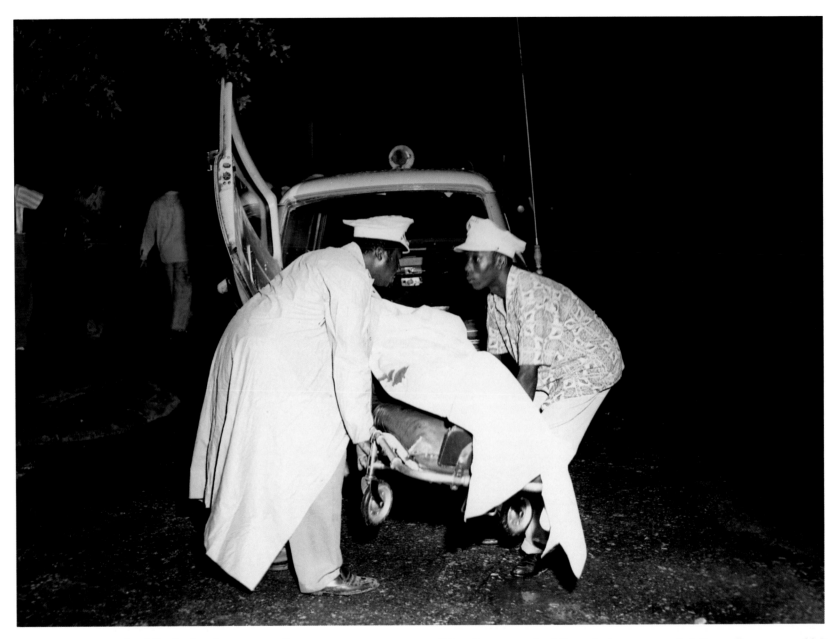

69. Murder by shotgun, 1958.

"A policeman and white ambulance came, but the policeman wouldn't allow the body to go into the ambulance. They had to wait until the black ambulance got there."

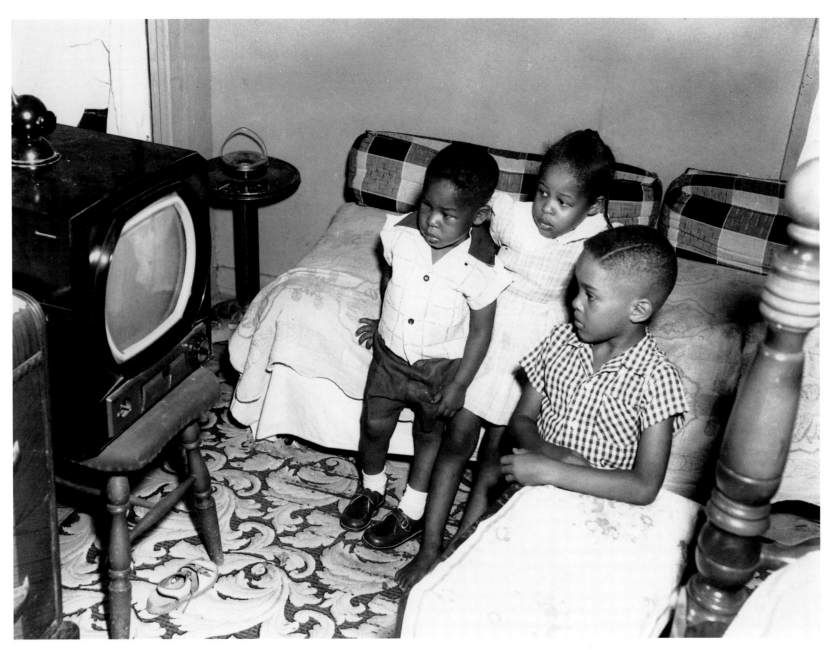

"My picture tells a story. Just look at the picture and you don't have to read anything."

70. The new TV, 1956.

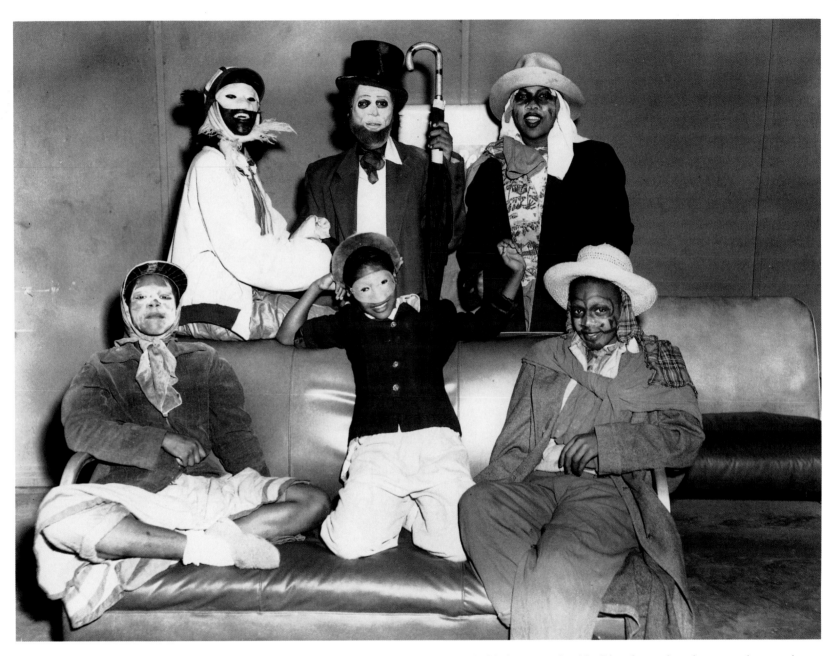

71. Trick or treat, 1954.

"[He] decided to wear the Abe Lincoln mask and costume because it was unusual."

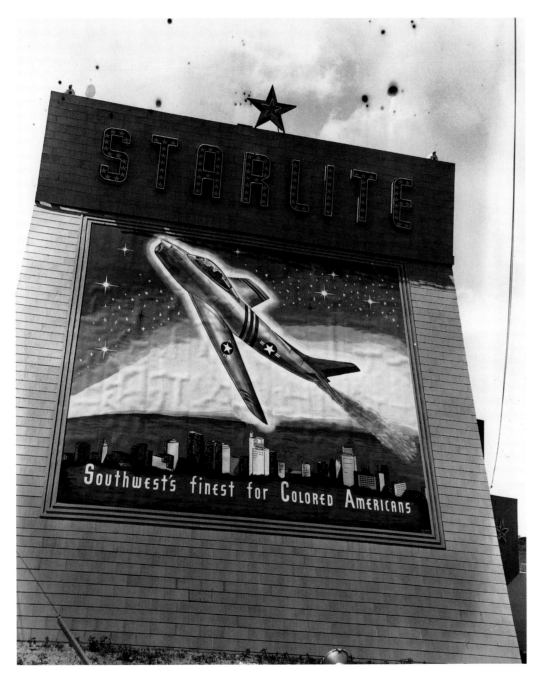

72. Starlite Theater marquee, 1953.

"The Starlite was the first drive-in movie opened in the black community."

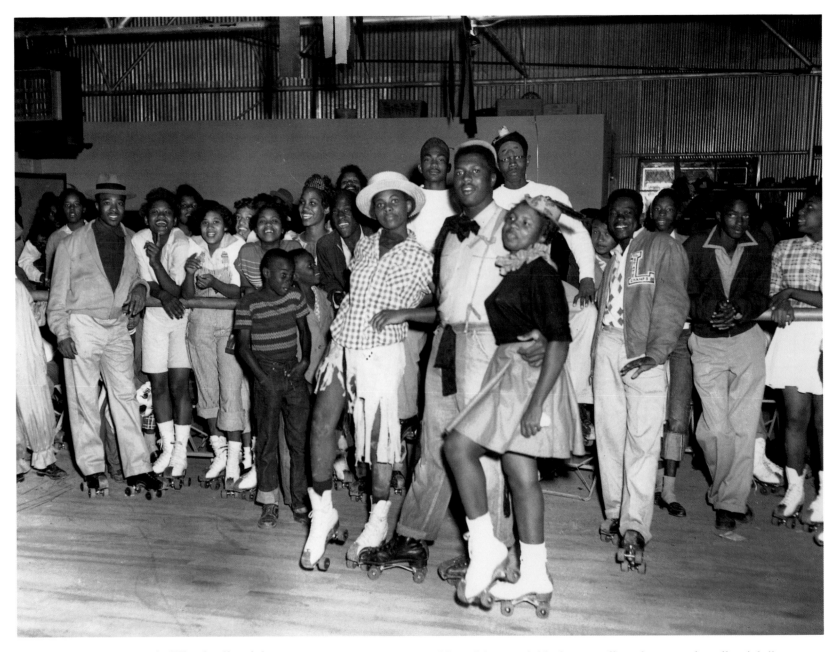

73. Magic Wheel roller rink, 1954. "One night a week blacks were allowed to go to the roller rink."

"Colored Day at the Fair. It was only a few short years ago that we could attend the State Fair on only one day. You could buy a ticket on other days, but you couldn't eat at any of the food stands, ride any of the rides, or enter any of the contests. But they would take your money at the gate and let you in."

74. Miss Wiley College in the State Fair parade, 1950.

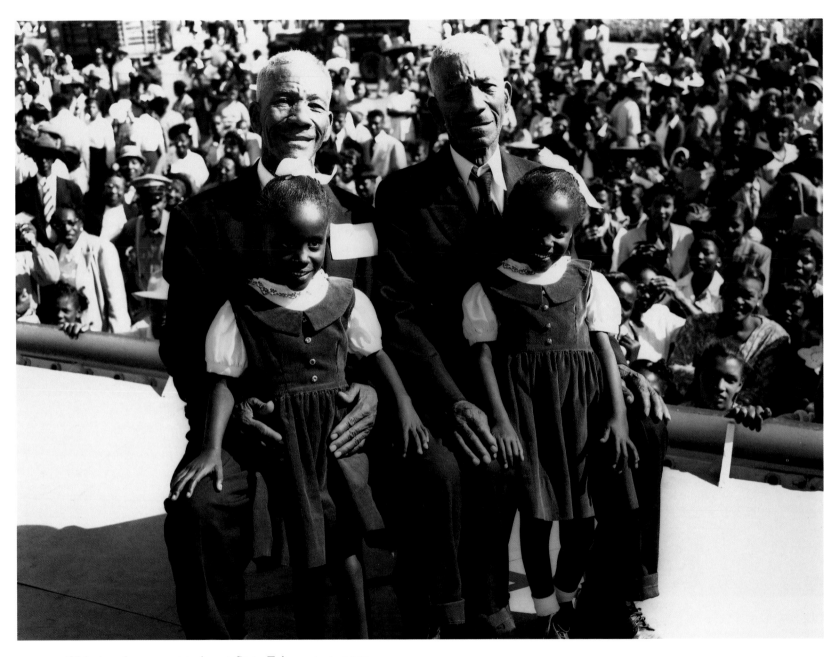

75. Oldest and youngest twins at State Fair contest, 1950.

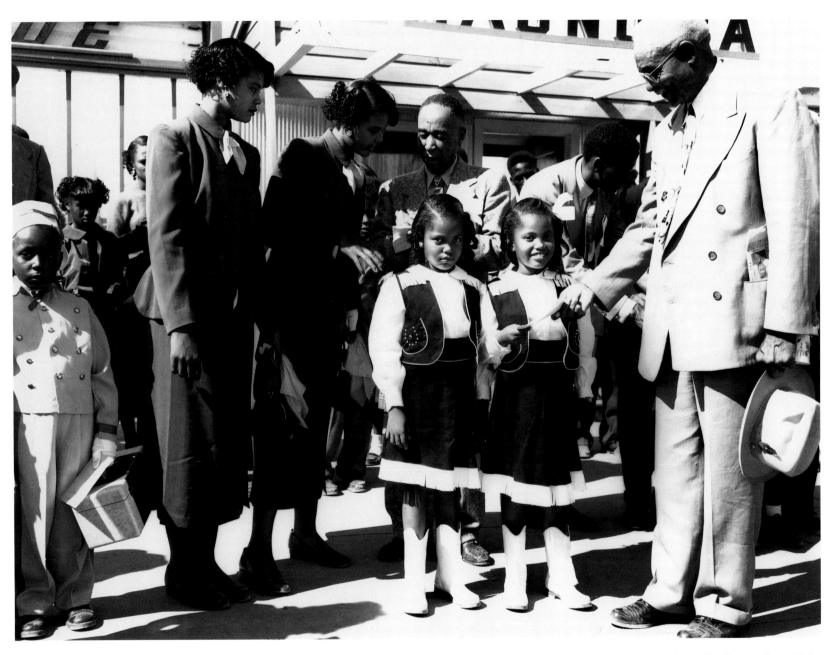

76. Twins Ina and Nina Daniels on the Magnolia Stage, State Fair,
1950.

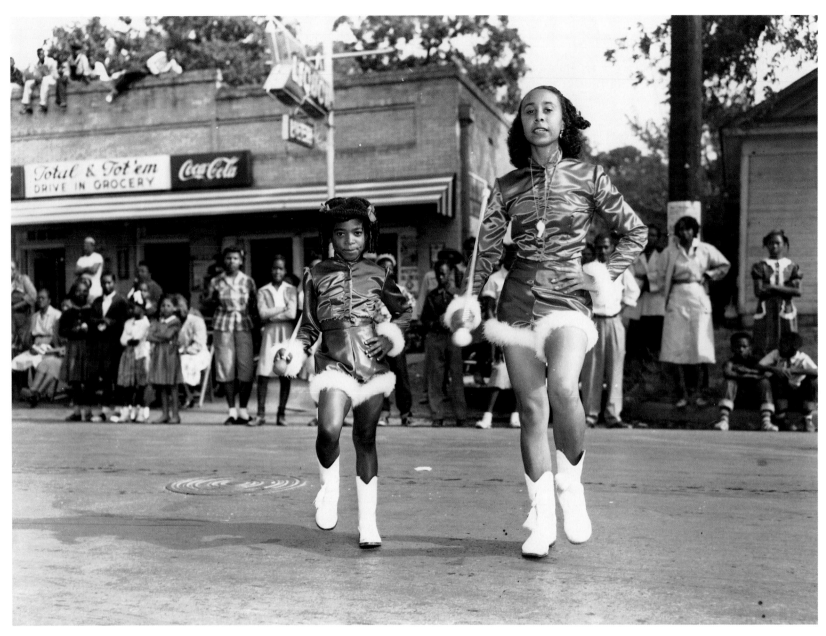

77. Sisters in the State Fair parade, 1953.

"There was one day set aside for blacks during the State Fair. They called it Negro Achievement Day. You talk about a parade! Bands, floats, beauticians, barbershop people, businesses, and colleges marched."

78. Miss Prairie View at the State Fair, 1957.

79. Danny Rogers and James Hill of the semipro Dallas Hornets, Burnett Field, 1954.

"When the Dallas Cowboys started in 1960 there was segregated seating in the stands. Then all of a sudden you could sit anywhere. But it really didn't change that much."

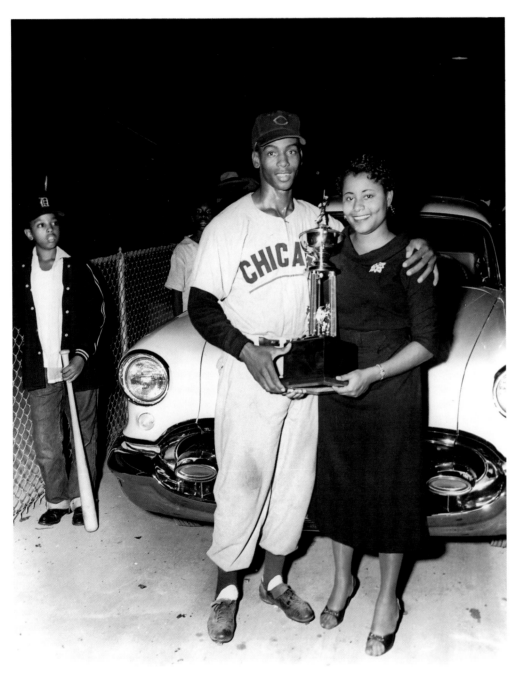

80. Ernie Banks, Chicago Cubs, 1955.

"My paper wanted a picture of Ernie Banks with his trophy. I asked his wife to step into the picture so it would attract a larger audience."

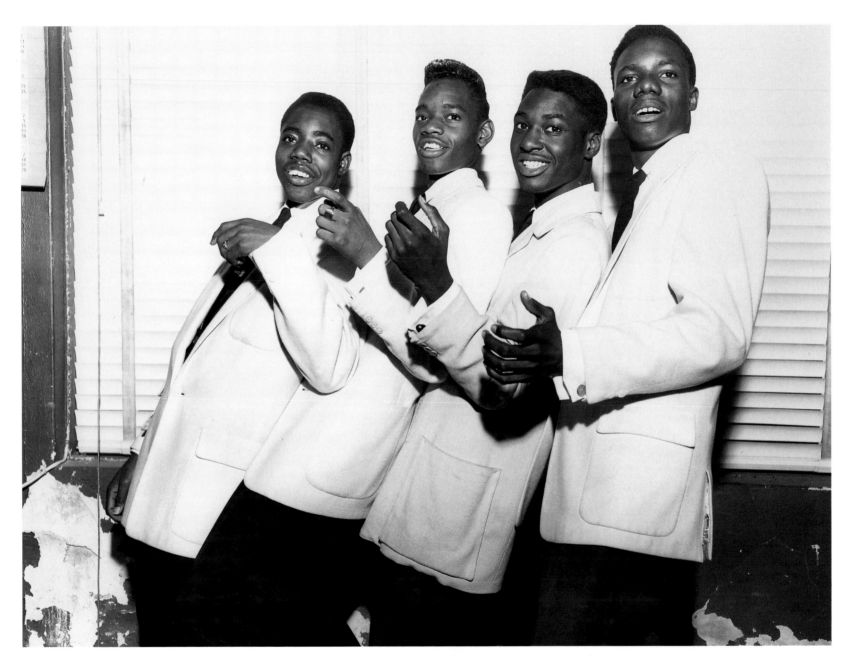

81. Mrs. Brown's Quartet, 1957.

82. Four boy performers, 1954.

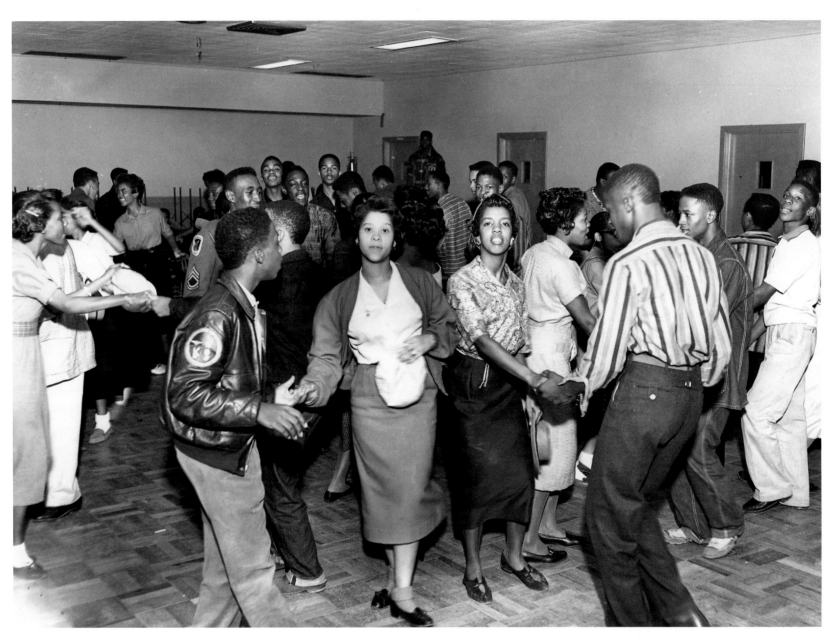

83. Teenage club dance, 1958.

"You have to keep in mind the kind of film you are using, the lighting, the aperture, and time. All of that has to blend in with your subject in order to shoot a good picture."

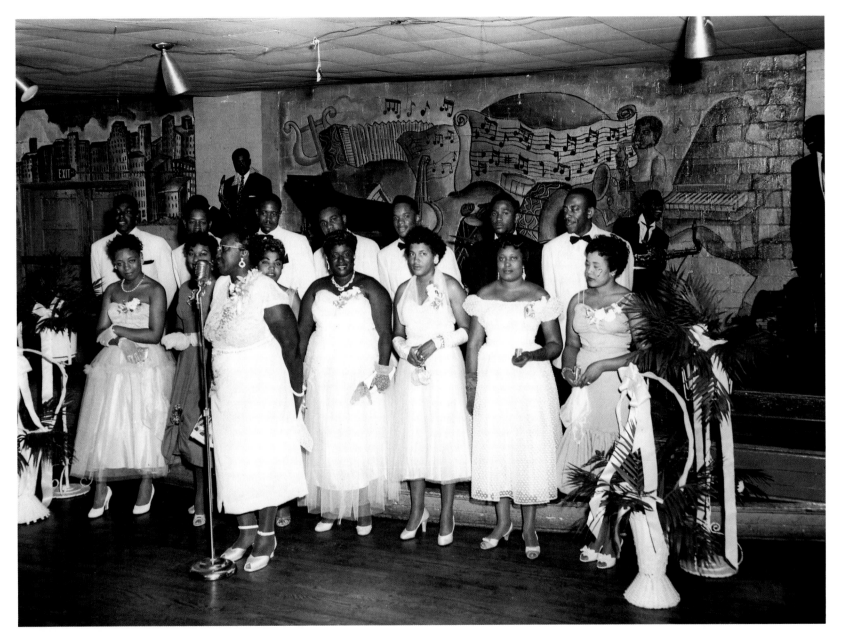

"Howard Lewis [the owner] was the big promoter for black bands in the Dallas/Fort Worth area. He would only promote black bands, black musicians, artists, or celebrities."

84. Empire Room, 1954.

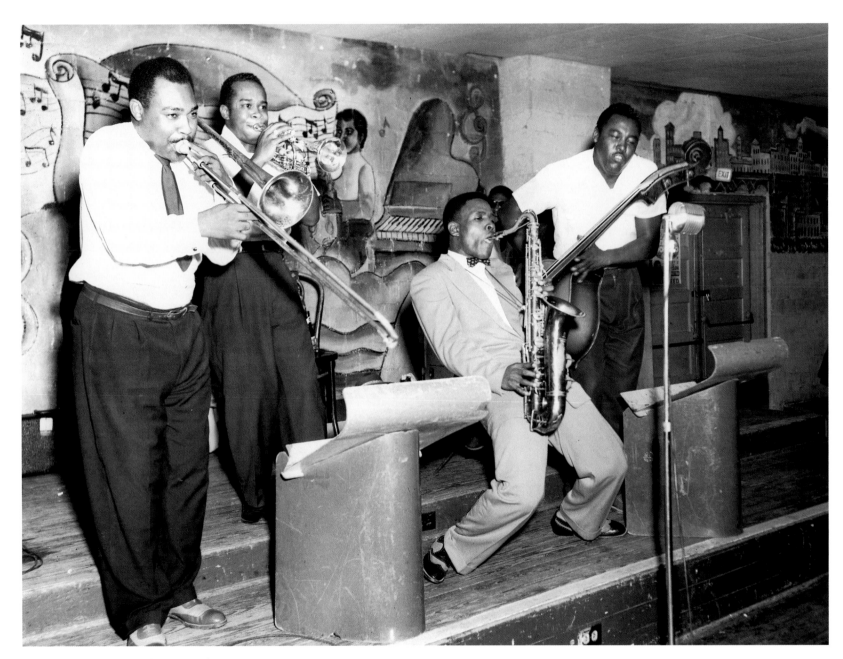

85. Joe Johnson, 1954.

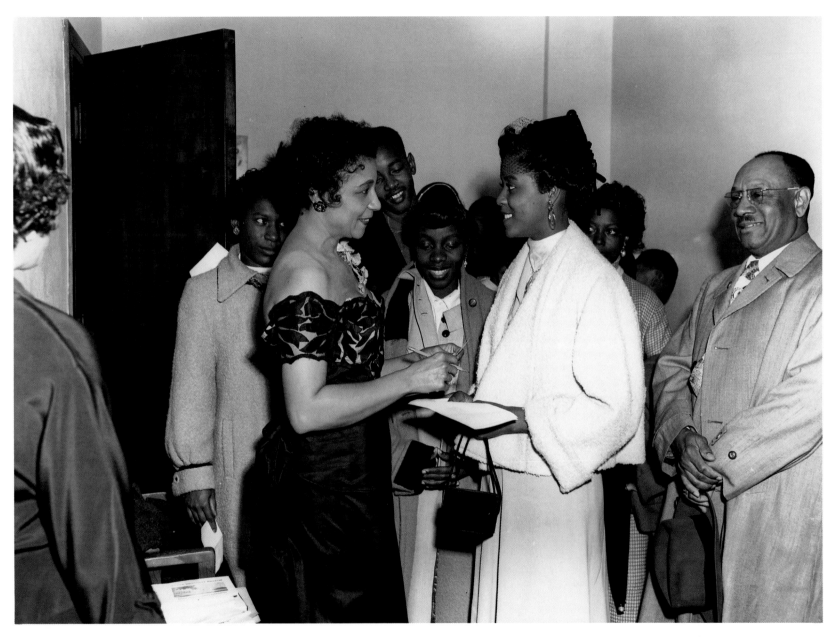

"Blacks could go to the Dallas Fair Park Music Hall on certain occasions and we were allowed to buy tickets like anybody else. But we had to sit in a separate seating section."

86. Etta Moten signs autographs backstage, 1954.

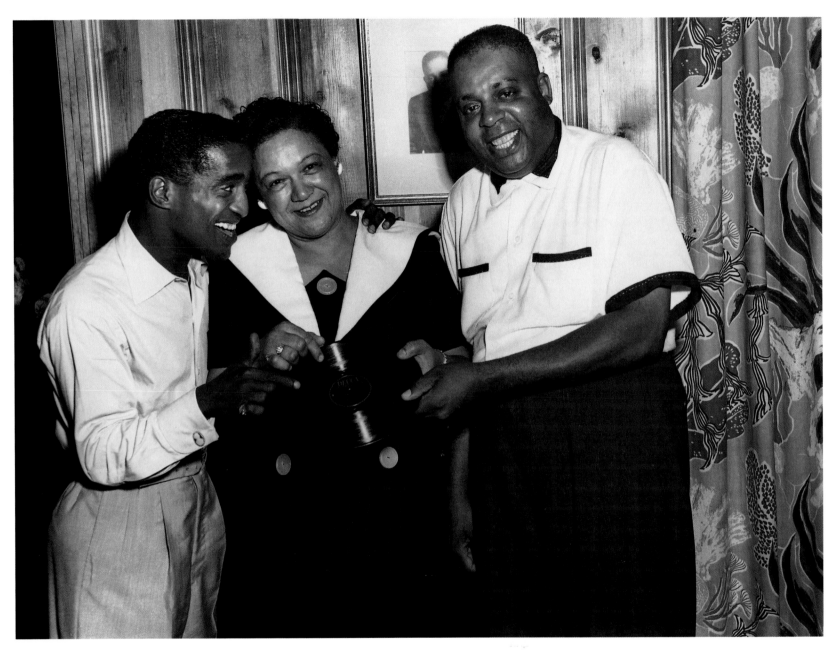

87. Sammy Davis Jr. with Mr. and Mrs. Peter Lane, 1954.

"This picture is from a party the Lanes gave after the grand opening of their hotel on Flora Street."

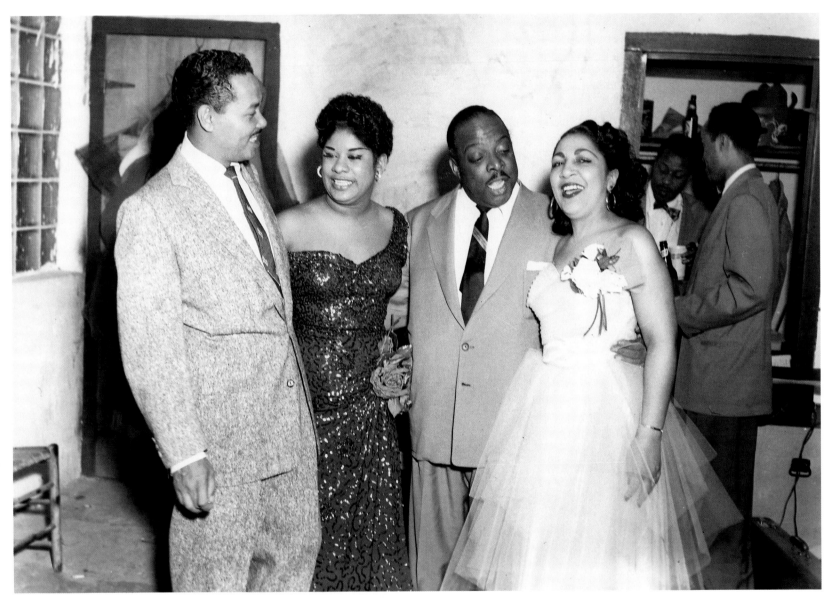

"*Jet* magazine would tell me, 'Billy Eckstine will be at the Longhorn Ranch House on Monday night. We need photographs of the audience, photographs of the band, and photographs of Eckstine singing. In other words, we want a complete photographic coverage of Billy Eckstine at the Longhorn Ranch House.' Sometimes that would be ten pictures."

88. Billy Eckstine, Ruth Brown, Count Basie, and unidentified woman at the Ranch House, 1953.

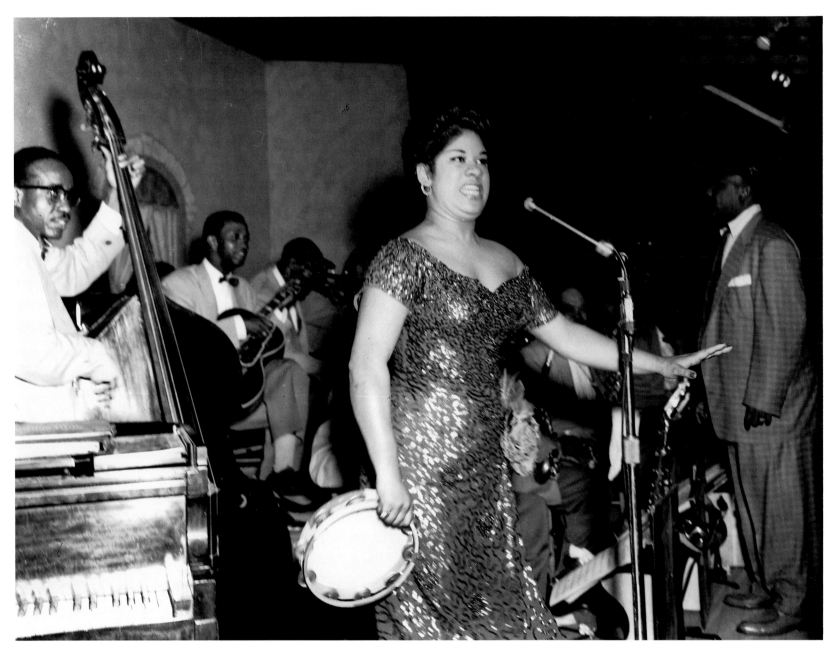

89. Ruth Brown at the Ranch House, 1953.

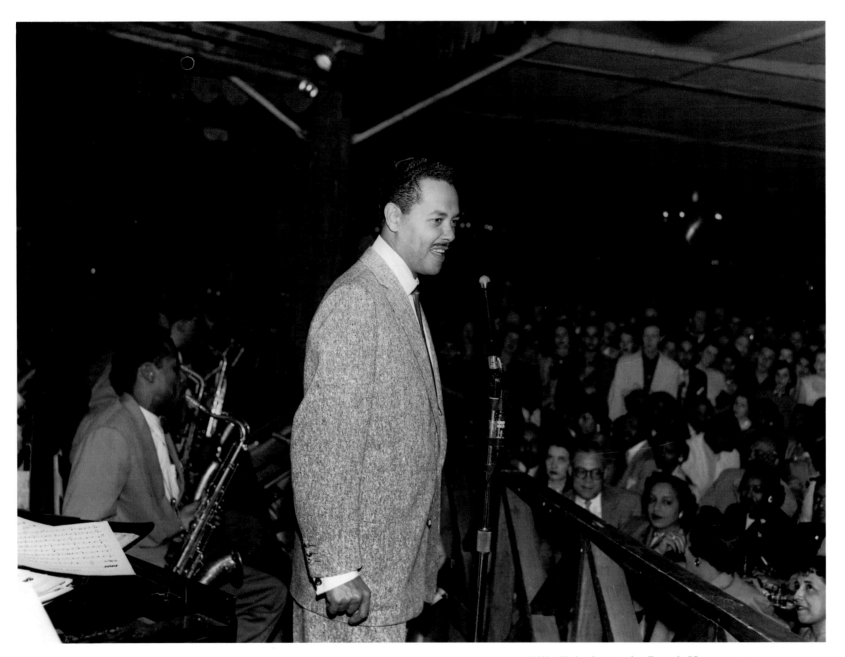

90. Billy Eckstine at the Ranch House, 1953.

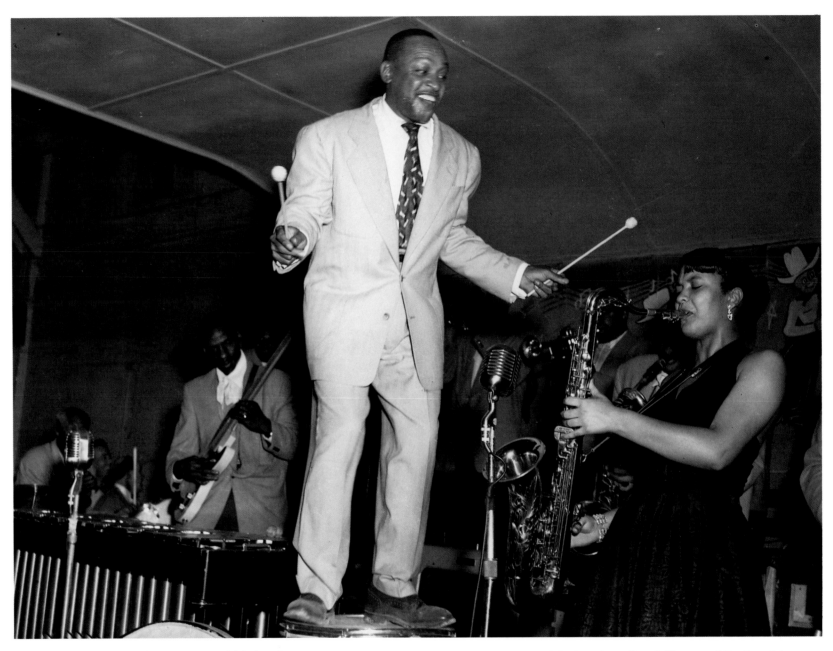

91. Lionel Hampton and his band, 1953.

"We could only attend the Longhorn Ranch House on Monday night, even if there was a black celebrity performing."

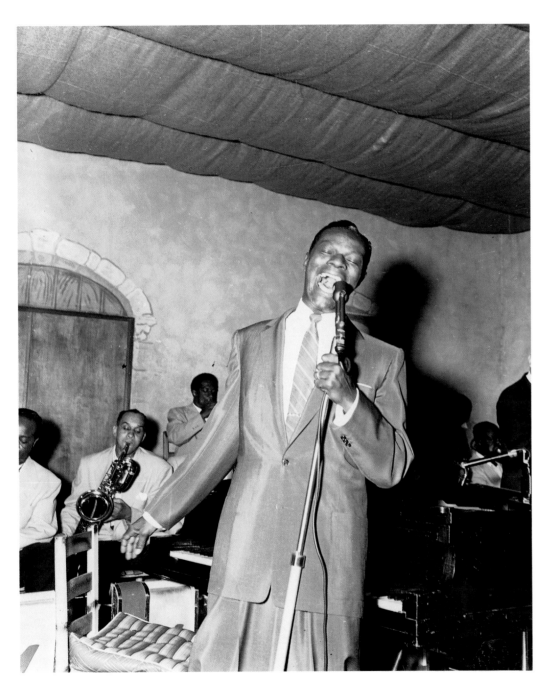

92. Nat King Cole, 1954.

"When Nat King Cole performed at the State Fair for white people, they let me in because I had this big camera. My camera allowed me to go anywhere. I sat on the front row and shot all I needed to shoot."

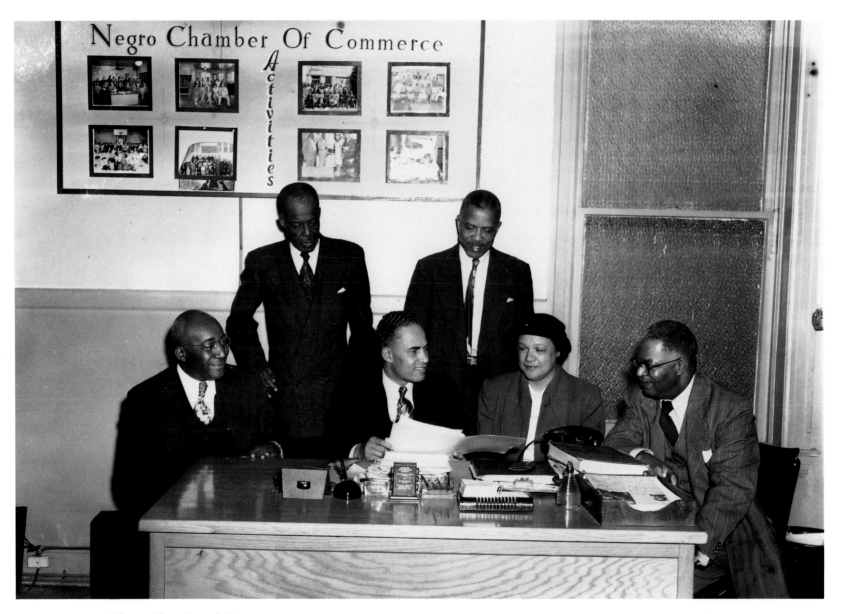

93. Negro Chamber of Commerce, 1957.

"The leadership of Dallas—white and black—didn't want a big problem with integration, so integration happened slowly so as not to upset the status quo. In the '60s they said, 'There isn't going to be any Watts, Los Angeles, Detroit, Chicago, or Birmingham. It's not going to happen here.' And it didn't."

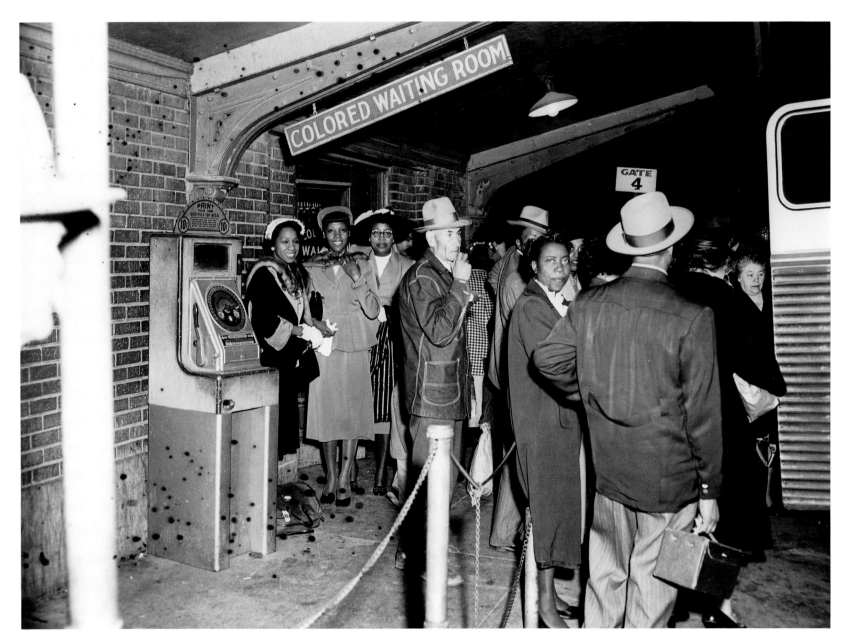

"Those signs in downtown Dallas, the signs over the water fountains and in the bus stations, came down in 1955 or '56, and a couple of years later they began to adhere to the Supreme Court decision."

94. Colored waiting room, 1952.

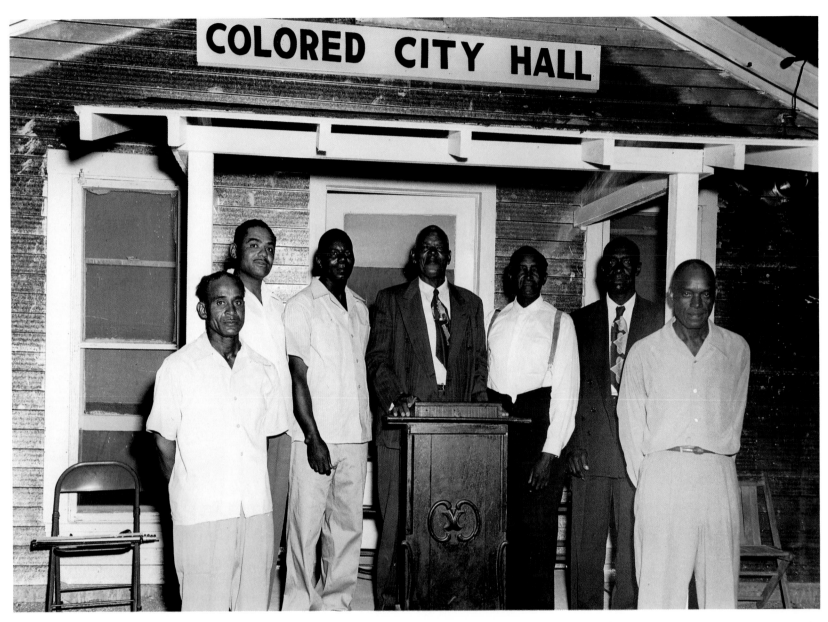

95. Colored City Hall, Italy, Texas, 1953.

"I got a telegram from *Jet* magazine that said 'R. C., we want you to go to Italy, Texas, and photograph the installation of officers of the only col-

ored city hall we know about in the world.' . . . Then I got another telegram that said, 'R. C., go back and get a picture of the white city hall.' I said, 'Oh my goodness.' I had been chased out of other places already for doing this sort of stuff.' "

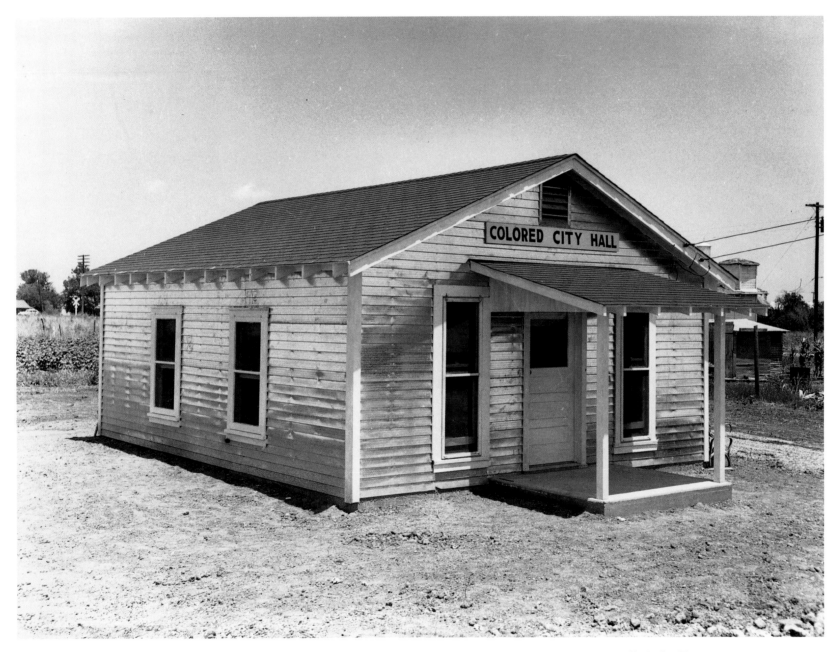

This photograph was published in the August 20, 1953, issue of *Jet*.

96. Colored City Hall, Italy, Texas, 1953.

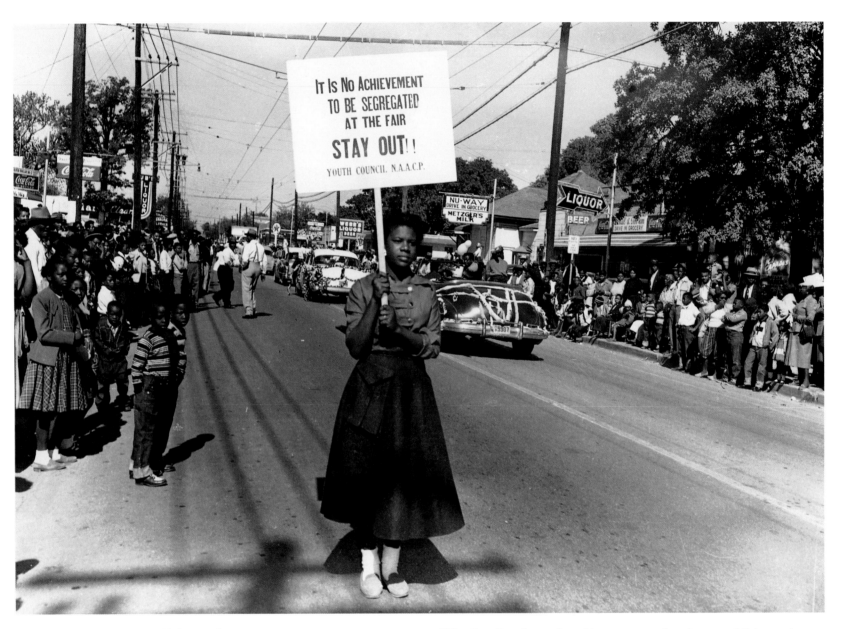

97. State Fair parade protest, 1955.

"The *Star Post* knew the white press wasn't going to publish our demonstrations and picketing for equal rights. We wanted to be sure that blacks knew what was going on and the only way they were going to know it was to put it in the newspaper."

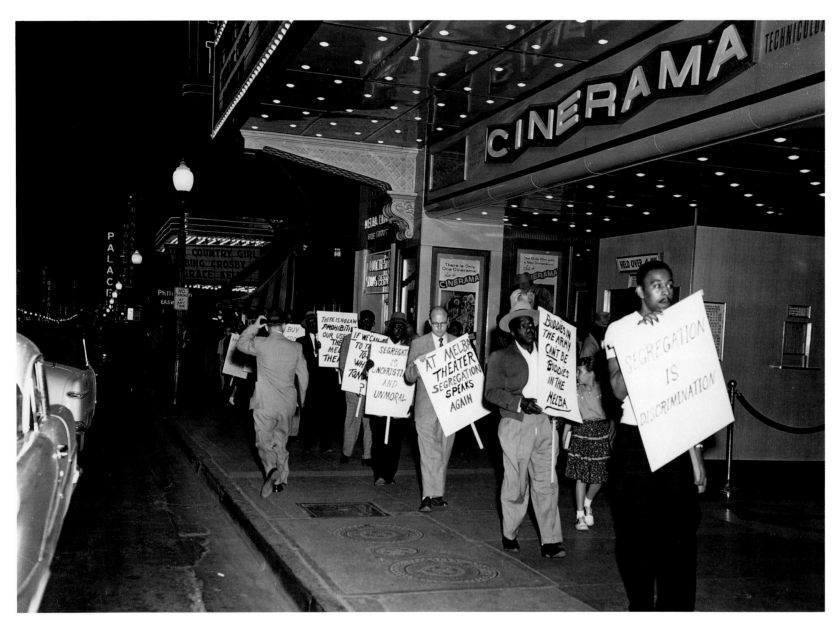

"There was only one theater in downtown Dallas we were allowed to at-
tend and that was the Majestic. Even there, we were only allowed into six
or seven seats in the uppermost part of the balcony we called the 'buzzard
roost.'"

98. Melba Theater, 1955.

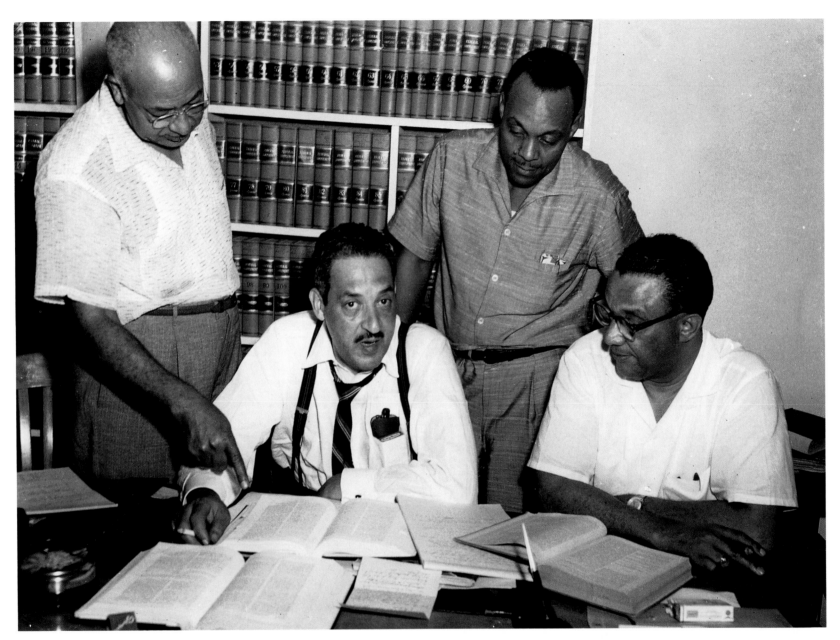

99. Thurgood Marshall, NAACP attorney, preparing suit to integrate the Dallas Independent School District, 1956.

Left to right: U. S. Tate, Thurgood Marshall, C. B. Bunkley, and W. J. Durham.
"With Thurgood Marshall in town, Dallas backed down."

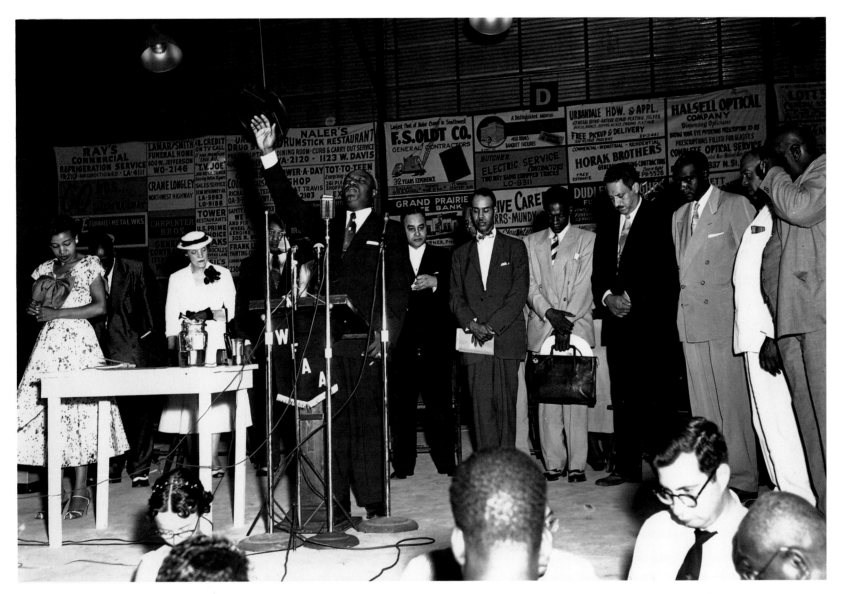

Left of speaker Rev. Ira B. Loud, Dr. Ralph Bunche; at right, NAACP
President Roy Wilkins and NAACP attorney Thurgood Marshall.
"When Benjamin Hooks was speaking at the NAACP convention in 1984
he said, 'Isn't it nice they let us come down here to these nice facilities and
let us stay in the hotels.' The audience went crazy. The last time the con-
vention was in Dallas was in 1954."

100. NAACP 45th Annual Convention, 1954.

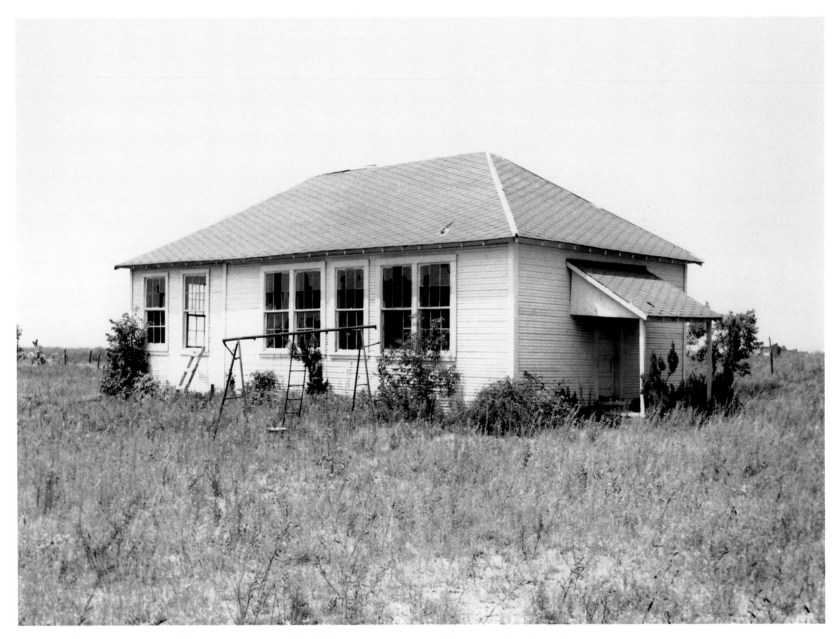

101. "Separate but equal" schools, Euless (NAACP), 1950.

"Each time the NAACP took a school district to court that called themselves 'separate but equal,' we proved through my photographs that the schools were certainly segregated, but not equal."

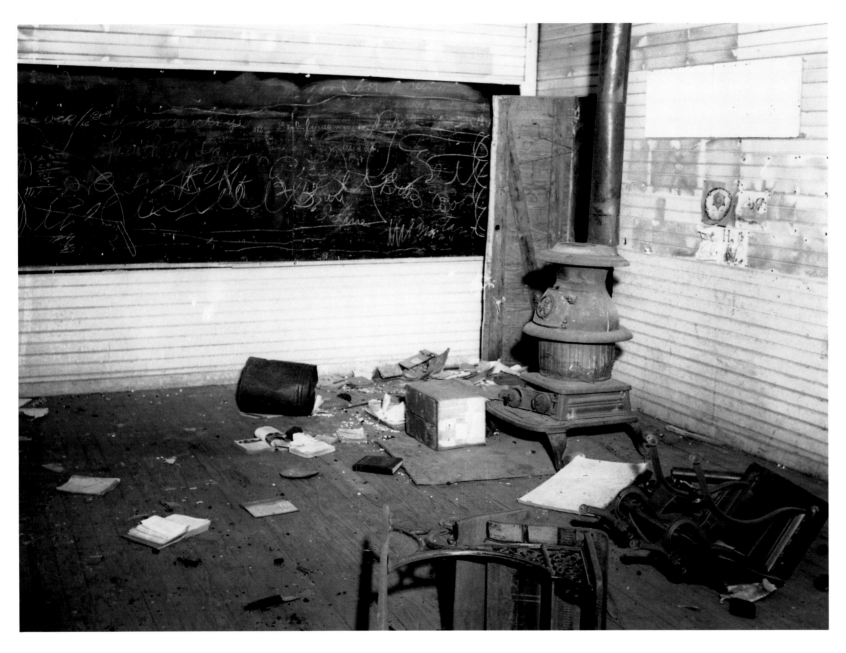

"You know, they didn't have a heater like that in any white school."

102. "Separate but equal" schools, Euless (NAACP), 1950.

103. Blacks hanging in effigy, Mansfield High School, 1956.

"I took my camera—it's a great big 4 x 5 Speed Graphic—and shot a picture one time. I'm a one-time man, you know. I put that camera back in the car and got out of town."

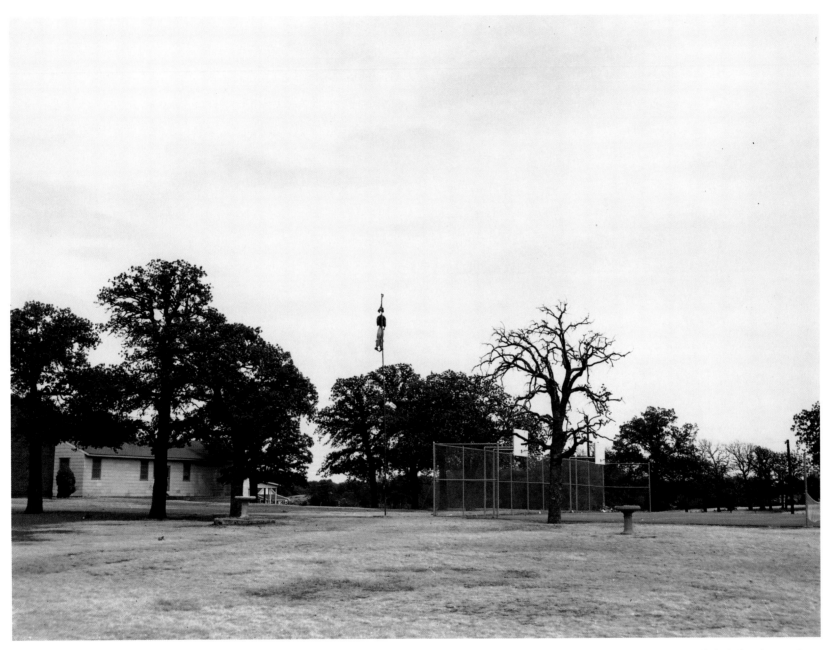

104. Blacks hanging in effigy, Mansfield High School, 1956.

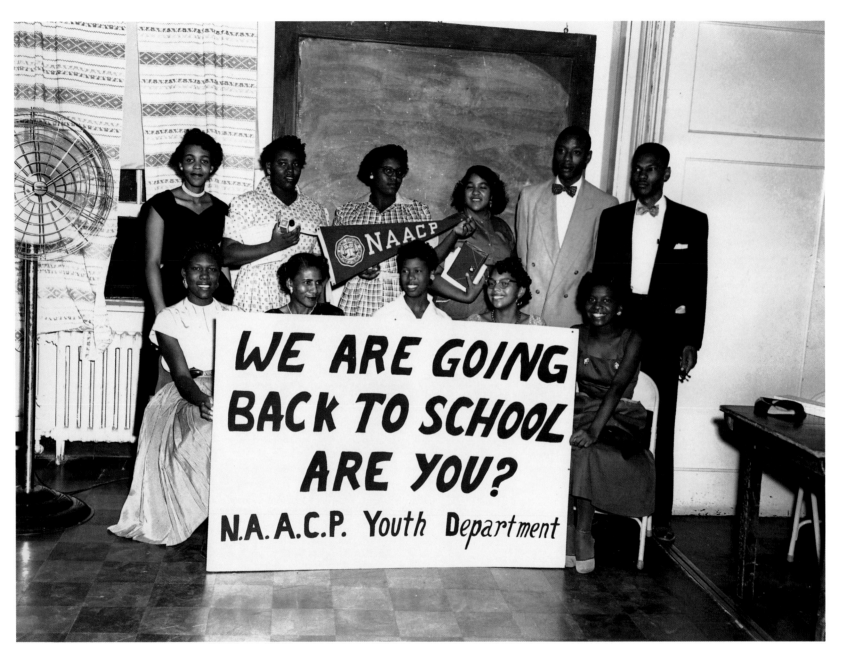

105. Going back to school, 1956.

"In my graduating class, twice as many girls as boys graduated."

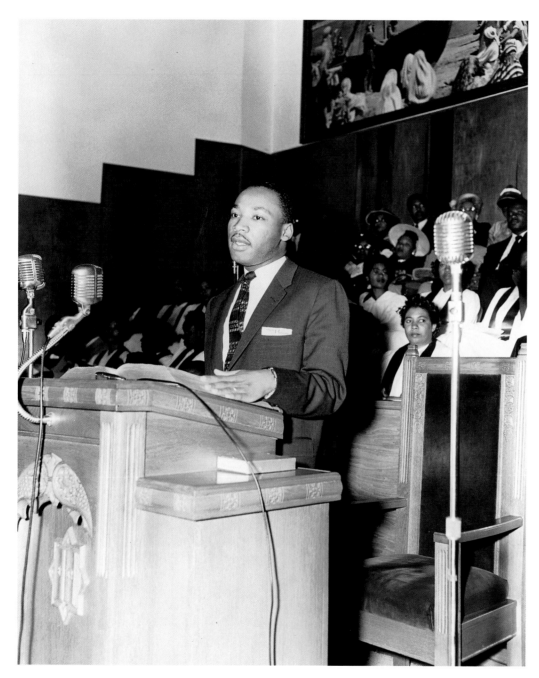

106. Dr. Martin Luther King Jr. at Good Street
Baptist Church, 1956.

"I just happened to get there at the right time."
"I was in a hurry. I took just one shot."

107. United Nations Ambassador Ralph Bunche, 1958.

In 1950, Bunche became the first black American to win the Nobel Peace Prize for mediating the 1949 conflict over Palestine between Israel and Arab nations.

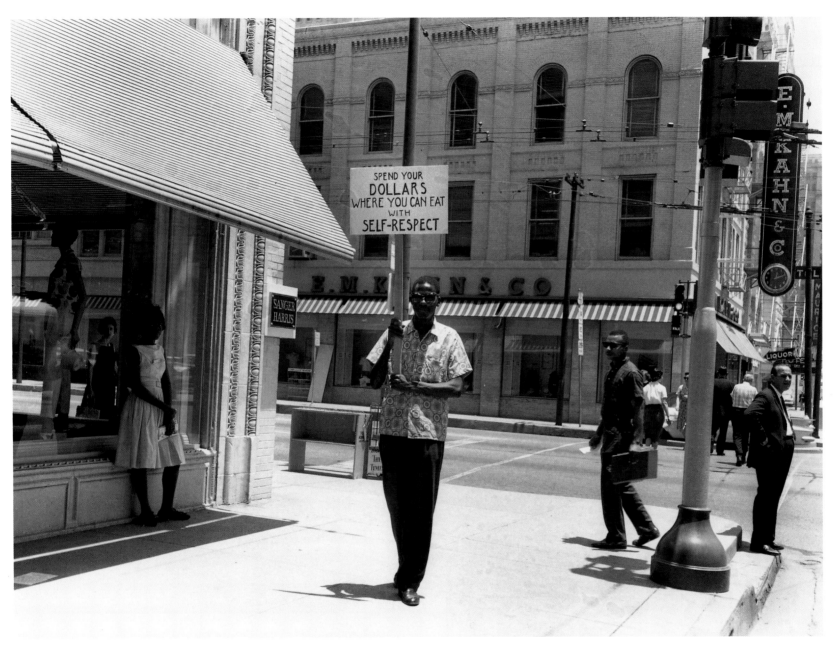

"The ladies couldn't try on anything they wanted to buy. They had to just look at it and say 'This is my size.'"

108. Spend Your Dollars Where You Can Eat with Self-Respect (Sanger-Harris department store), 1961.

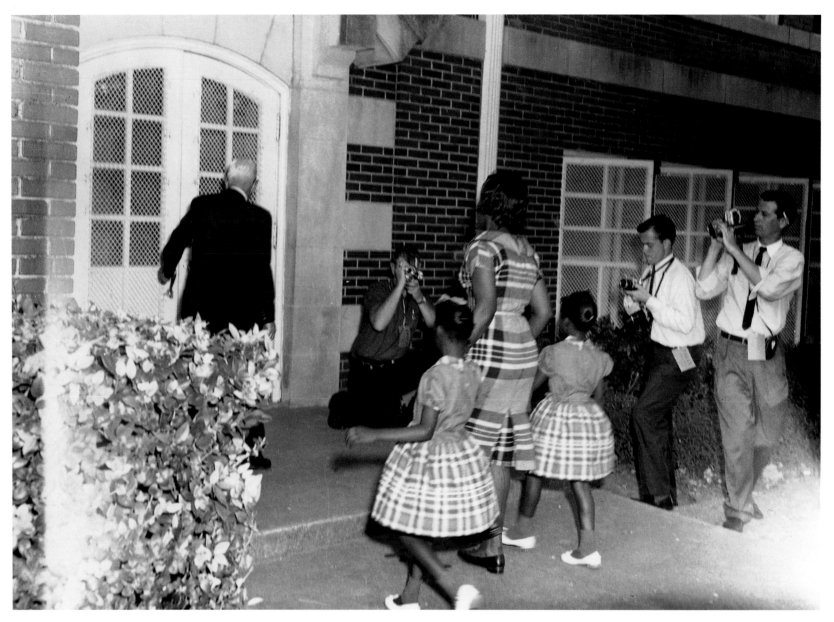

109. Integrating the Dallas public schools, 1961.

Dollie Miles and her twins, City Park Elementary School.
"Dallas did not integrate readily. According to the law they had to integrate the schools, public transportation, and medical facilities. What they had to do, they did."

BIBLIOGRAPHY

Publications

Anderson, Bernard E. *The Opportunities Industrialization Centers: A Decade of Community-Based Manpower Services*. Manpower and Human Resources Studies, no. 6. Philadelphia: Industrial Research Unit, Wharton School, University of Pennsylvania, 1976.

Banks, Melvin J. *The History of the New Hope Baptist Church: A Century of Faith*. Dallas: New Hope Baptist Church, 1967.

Bessent, Nancy Echols. The Publisher: A Biography of Carter Wesley. M.A. thesis, University of Texas at Austin, 1981.

Coar, Valencia Hollins. *A Century of Black Photographers, 1840–1960*. Providence, R.I.: Museum of Art, Rhode Island School of Design, 1983.

Fulton, Marianne. *Eyes of Time: Photojournalism in America*. Boston: Little Brown & Co., 1988.

Ghiglione, Loren. *The American Journalist: Paradox of the Press*. Washington, D.C.: Library of Congress, 1990.

Gillette, Michael. The NAACP in Texas, 1937–1957. Ph.D. diss., University of Texas at Austin, 1984.

Grose, Charles W. Black Newspapers in Texas, 1868–1970. Ph.D. diss., University of Texas at Austin, 1972.

Johnson, Vivian Williamson. Reclaiming the Past: The History of Freedman's Town and the Preservation of its To-Gun/Shotgun House, 1906–1910. M.A. thesis, Southern Methodist University, 1988.

Jones, Monty. "Prints Focus on Ignored Community," Austin *American-Statesman*, February 28, 1987.

Kenny, Steve. "The Struggle for Power." *D Magazine*, June 1981, 98–99, 136–144.

Lemann, Nicholas. "Power and Wealth." In *Texas Myths*, edited by Robert F. O'Connor. College Station: Texas A&M University Press, 1986. pp. 159–173.

Melosi, Martin. "Dallas-Fort Worth, Marketing the Metroplex." In *Sunbelt Cities: Politics and Growth Since World War II*, edited by Richard M. Berand and Bradley R. Rice. Austin: University of Texas Press, 1983.

———. "Dallas-Fort Worth: Politics, Economy and Demographics Since World War II." *Public Administration Series*. Bibliography #P986. Monticello, Ill.: Vance Bibliographies, 1982.

Morgan, Willard D., and Henry M. Lester. *Graphic Graflex Photography*. New York: Morgan and Lester Publishers, 1940.

Norton, Mary Beth, and David M. Katzman, et al. *A People & A Nation—A History of the United States*. Vol. 2, *Since 1865*. 3rd ed. Boston: Houghton Mifflin Co., 1990.

Report of the National Advisory Commission on Civil Disorders. New York: E. P. Dutton, 1968.

Schutze, Jim. *The Accommodation: The Politics of Race in an American City*. Secaucus, N.J.: Citadel Press, 1986.

Wade, Norma Adams. "Army Job Develops into 30-year Career." Dallas *Morning News*, February 10, 1986.

Westfeldt, Wallas. "Communities in Strife." In Southern Education Reporting Service, *With All Deliberate Speed: Segregation—Desegregation in Southern Schools*, edited by Don Shoemaker. New York: Harper, 1957.

Willis-Thomas, Deborah. *Black Photographers, 1840–1940: An Illustrated Bio-Bibliography*. New York: Garland Publishing, 1985.

Other Media

"Black Photographers Bear Witness: 100 Years of Social Protest, 1889–1989." Williams College Museum of Art. Presented in Dallas, Texas, by the Museum of African-American Life and Culture, Summer, 1990. Exhibition.

"Black Presence in Dallas: A History of Black Political Activism in Dallas." Presented in Dallas, Texas, by the Museum of African-American Life and Culture, March 5–April 15, 1987. Exhibition.

Logan, Ramona. "Focused on Change." K-TV, February 1990. Video.

Interviews and Telephone Conversations

Hall, J. D. Interview with Sherilyn Brandenstein. Dallas, Texas, August 10, 1990.

Hickman, R. C. Interview by Sherilyn Brandenstein, February 27, 1987. Transcript, R. C. Hickman Collection, Center for American History, University of Texas at Austin.

Hickman, R. C. Interview with Sherilyn Brandenstein. Dallas, Texas, August 10–11, 1990.

Hickman, R. C. Telephone conversation with Sherilyn Brandenstein, January 23, 1991.

James, H. Rhett. Telephone conversation with Sherilyn Brandenstein, January 25, 1991.

Johnson, Roosevelt. Telephone conversation with Sherilyn Brandenstein, November 5, 1990.

Johnson, Vivian Williamson. Telephone conversation with Sherilyn Brandenstein, February 1, 1991.

McKenzie, Jewel. Interview with Sherilyn Brandenstein. Dallas, Texas, August 11, 1990.

PLATES AND NEGATIVE NUMBERS

Plate no.	Title	Negative no.
1	Papa Dad's Bar-B-Que	90-135-000017 a
2	Clark's Liquor Store	90-135-000033 a
3	Smith Bros. Drug Store (fire)	90-135-000008 b
4	Palms Barber and Beauty Shop (fire)	90-135-000008 a
5	Young newscarrier delivering paper in coat and cowboy boots	85-43-000014
6	Hickman family-owned BAR-20 store in Mineola, Texas	85-260-000068
7	R. C. with Speed Graphic camera, by unidentified photographer	CN 07647
8	Maypole dance at West Dallas Elementary School	85-152-000003 f
9	Mrs. R. C. (Ruth) Hickman and debutante Shirley Elliott	85-152-000192 a
10	Ella Fitzgerald	85-43-000212 a
11	NAACP photo	85-43-000182
12	Joe Louis and Ruth Brown at the Aristocrat Restaurant	85-43-000152 f
13	Medical Clinic	90-135-000027 b
14	Rev. Brooks E. Joshua and two slain deer	85-152-000190 a
15	Mr. Green's housewarming	85-152-000415 a
16	After the fire	85-43-000029 a
17	Dallas Opportunities Industrialization Center. Clerk typing/retail sales class	85-152-000950 b
18	An evening at Dr. Hughes's house	85-152-000196
19	Grandfather with his four charges	85-152-000161 d
20	Group of women in formal dress	85-152-000161 a
21	Garden Club tea	87-214-000179
22	Three girls in front of car	85-43-000047
23	Three young women playing in the snow	85-43-000179 a
24	Group of children building a snowman	85-43-000072
25	Mrs. Prince	85-152-000004 a
26	Woman with two children	85-43-000119
27	Young woman on lawn (Mrs. Parker)	85-43-000109 a
28	Another young woman on lawn	85-43-000183 b
29	Miss Beverly	85-152-000118
30	Betty on lawn	85-43-000020 e
31	Record Shop	85-152-000059 a
32	Dallas *Express* meeting	85-43-000065 a
33	Dallas *Star Post* office	85-43-000199 c
34	Group of boys and men in front of *Star Post*	85-43-000177
35	R. C. Hickman at desk	85-43-000200 a
36	W. J. Durham, copublisher of *Star Post*, and secretary	85-43-000200 d
37	Linotypist, *Star Post*	85-43-000200 f
38	Machinist and presser T. O. Love, *Star Post*	85-43-000200 g
39	Woman at press, *Star Post*	85-43-000200 n
40	Linotypists Howard Trigg and O. A. Branch, *Star Post*	85-152-000060 c
41	Whipple Realty and newscarriers	85-152-000110
42	Bobbie the newsboy	85-43-000096
43	Dr. Lee G. Pinkston and family	85-43-000315 a
44	Dr. Pinkston and wife	85-43-000315 e
45	Testimonial banquet for Dr. Pinkston, YMCA	85-43-000314 a
46	Working Dr. Lee Pinkston's Farm	85-43-000074
47	Camp Pinkston picnic for newscarriers	85-43-000175
48	Mr. and Mrs. Johnson at KLIF	85-152-000002 a

49	Mr. and Mrs. Johnson at their restaurant	85-152-000002 c
50	Jim Randolph, KLIF disc jockey	85-43-000222 b
51	Mac's Texaco	85-152-000132 a
52	Service station owner Annie Carr Mercer	87-214-000295 a
53	Thrifty Drug pharmacist	85-152-000076
54	Red Cross nurse's class	85-152-000148 a
55	The girls of the Aristocrat	85-43-000042
56	Woman barber	87-214-000298 b
57	Catholic funeral at church	85-43-000016 b
58	St. John Missionary Baptist Church	85-43-000303 a
59	Church gathering at private home	85-43-000100
60	China tea, Forest Avenue Baptist Church	88-164-000285
61	"Extending our Horizons" award: Coach Edmunds gets plaque	85-43-000010
62	Elks with Christmas gifts	87-214-000218
63	Shriners	85-43-000308 a
64	Boy Scout	85-43-000122 a
65	High school boy receives scholarship	85-43-000048
66	Mrs. Murray's son flies home	85-43-000050 a
67	Exline Park	85-43-000020 c
68	Eviction	85-43-000151 a
69	Murder by shotgun	85-43-000146 c
70	The new TV	85-43-000056 a
71	Trick or treat	85-43-000002
72	Starlite Theater marquee	85-260-000014
73	Magic Wheel roller rink	85-152-000219 a
74	Miss Wiley College in the State Fair parade	85-43-000317 e
75	Oldest and youngest twins at State Fair contest	85-43-000317 g
76	Twins Ina and Nina Daniels on the Magnolia Stage, State Fair	85-43-000317 i
77	Sisters in the State Fair parade	85-43-000326 b
78	Miss Prairie View at the State Fair	85-43-000206 a
79	Danny Rogers and James Hill of the semipro Dallas Hornets, Burnett Field	85-43-000244
80	Ernie Banks, Chicago Cubs	85-43-000235 a
81	Mrs. Brown's Quartet	85-43-000084 b
82	Four boy performers	85-43-000036 b
83	Teenage club dance	87-214-000250 c
84	Empire Room	85-152-000296 a
85	Joe Johnson	85-43-000036 d
86	Etta Moten signs autographs backstage	85-152-000177
87	Sammy Davis Jr. with Mr. and Mrs. Peter Lane	85-43-000300 d
88	Billy Eckstine, Ruth Brown, Count Basie, and unidentified woman	85-43-000230 a
89	Ruth Brown at the Ranch House	85-43-000230 b
90	Billy Eckstine at the Ranch House	85-43-000230 d
91	Lionel Hampton and his band	85-43-000232 e
92	Nat King Cole	85-43-000312 a
93	Negro Chamber of Commerce	86-301-000001
94	Colored waiting room	85-43-000209 d
95	Colored City Hall, Italy, Texas	85-43-000255 b
96	Colored City Hall, Italy, Texas	85-43-000255 i
97	State Fair parade protest	90-135-000001 a
98	Melba Theater	85-43-000279 a
99	Thurgood Marshall, NAACP attorney	85-43-000210 a
100	NAACP 45th Annual Convention	85-43-000293 d
101	"Separate but equal" schools, Euless (NAACP)	85-43-000258 f
102	"Separate but equal" schools, Euless (NAACP)	85-43-000258 d
103	Blacks hanging in effigy, Mansfield High School	85-43-000254 b
104	Blacks hanging in effigy, Mansfield High School	85-43-000254 c
105	Going back to school	85-43-000273
106	Dr. Martin Luther King Jr. at Good Street Baptist Church	85-43-000201 c
107	United Nations Ambassador Ralph Bunche	85-43-000274 b
108	Spend Your Dollars Where You Can Eat with Self-Respect	85-43-000285 a
109	Integrating the Dallas public schools	85-43-000284 a

Designed and printed at Wind River Press, Austin